IMAGES
of America

GLOUCESTER CITY

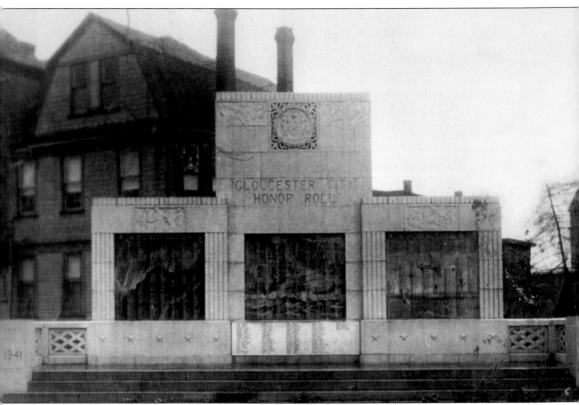

This is a monument to local war heros who died in service to the United States. The Gloucester City Advisory Committee is searching for photographs of Gloucester City veterans who gave their lives for America's freedom. Please contact the Gloucester City Clerk's Office at (856) 456-0205 if you would like to provide an image for the city's local war veterans banner project. (Courtesy of VFW Museum Post 3620.)

ON THE COVER: This image shows the staff of the Thompson's Hotel (see page 15 for more information). (Courtesy of Shad Agar.)

IMAGES
of America

GLOUCESTER CITY

Gabriel and Adrianne Parent
with the Gloucester City Historical Society

ARCADIA
PUBLISHING

Copyright © 2011 by Gabriel and Adrianne Parent with the Gloucester City Historical Society
ISBN 978-0-7385-7627-5

Published by Arcadia Publishing
Charleston, South Carolina

Printed in the United States of America

Library of Congress Control Number: 2011924268

For all general information, please contact Arcadia Publishing:
Telephone 843-853-2070
Fax 843-853-0044
E-mail sales@arcadiapublishing.com
For customer service and orders:
Toll-Free 1-888-313-2665

Visit us on the Internet at www.arcadiapublishing.com

*This book is dedicated to our grandfathers and all the
veterans who served our country in order to provide
freedom for us. We appreciate your sacrifice.*

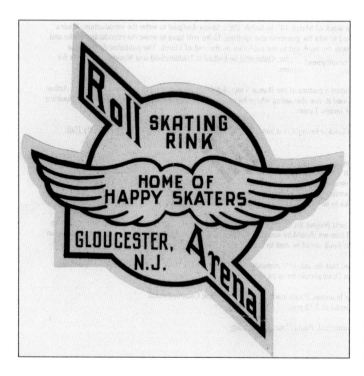

In the 1940s, the Gloucester City Roller Arena, which also included a bowling alley, was located at 418 Jersey Avenue. The recreation facility operated into the early 1950s. (Courtesy of the Parent family.)

CONTENTS

ACKNOWLEDGMENTS

Thanks go to David Munn and Louisa Llewellyn for writing, editing, and adding their expertise and knowledge to the project. We would like to thank all of the current and past members of the historical society who contributed tens of thousands of hours to preserve the history of Gloucester City and the surrounding areas. It is impossible to thank all of those volunteers individually, but without their hard work and their love of the local history, this book would not have been possible. We would like to thank the current members of the society: Dave Townsend, Paula Conroy, Sandy Peth, Will Lee, Linda Locker, and all of the other members. We would like to give credit to the following amazing people and the wealth of time and stories they provided, which helped produce this story: Ed Walens of the VFW Museum Post 3620, Shad Agar, Frank Anello Jr., the Martorano family, Barbara Price of the Gloucester County Historical Society, Paul W. Schopp, the Gloucester City Fire Department, the Gloucester City Utilities Department, Ed Kasuba and Chip Thompson of the Delaware River Port Authority, Patricia Robertson, Ron Baile, Bill and Dianne Fisher, Carol Ritchie, Anna May Nacella, the Carr family, the Duffy-Hall family, the Gannon family, Sandy Wiltsey, and Howard Clark for their encouragement on the project. Thank you, to all of the other nice Gloucester families who donated their time and welcomed us into their homes to learn more about the historical fabric of families in our tight-knit hometown. Without them, future generations would not realize to look at our past in order to create an amazing future.

Unless otherwise noted, all images appear courtesy of the Gloucester City Historical Society.

INTRODUCTION

The land upon which Gloucester City was first settled by the Dutch in 1623. Capt. Cornelius Mey, who worked for the second West India Company of Holland, sailed up the Delaware River and constructed a small fort along the shores. He named the fort Nassau, after a town located on the Upper Rhine River in Germany. Prior to the settlement of Fort Nassau, the Lenape Native American tribe inhabited the area. With just a hand full of farmers living in the area, the Dutch settlement stayed relatively small for over 50 years.

In 1686, the immigrant settlers of the area residing from Oldmans Creek to Pennsauken Creek met at Gloucester Point. The meeting resulted in the formation of a county constitution and creation of a court system. Due to the efforts of John Reading, Gloucester Point was the location chosen to house the county buildings, thus the newly created county seat was called Gloucester City. To commemorate this historic meeting of the West Jersey proprietors of the Third and Fourth Tenths, Gloucester City hosts an event every April.

Soon, a series of streets with a square in the center was laid out. Because the town served as the county seat, the freeholders (county legislators) required a jail, and Sheriff Daniel Reading constructed a "log gaol." In 1694, the freeholders ordered a courthouse, and a third jail was built on the southwest corner of the town square at the present-day intersection of King and Market Streets. The site of the town was at an ideal spot along the Delaware River for the transportation of goods. This led to several taverns operating as stagecoach stops.

In 1721–1722, Joseph Hugg built, most likely because of the newly constructed courthouse, a large tavern located on the waterfront and near the county buildings and his ferry. Hugg's Tavern served as the social, political, and military center of the town and county. The tavern stood as the largest structure in Gloucester County for many years. In 1758, county freeholders purchased a stove to be placed in the courthouse so that meetings could be held in the winter for the first time. The freeholders held their meetings in Hugg's Tavern during the winter, as did the courts. Throughout most of its history, the proprietors held their Gloucester elections under the buttonwood tree near the tavern. One of the most noteworthy events at the tavern was the marriage of John Ross to Elizabeth Griscom. She later became known as Betsy Ross, the so-called mother of the American flag.

In March 1786, a fire destroyed the courthouse, and the freeholders voted to move the county seat to the more populous Woodbury. Prior to this in 1779, so few people lived in Gloucester that nobody wanted to run for political office. To correct this, the state legislature created a bigger political area called Gloucestertown Township, which solved the problem for a time.

In the 1830s, with only a half dozen farms and less than 20 dwellings, Gloucester was folded into Union Township, with its main population centered in present-day Mount Ephraim. At the same time, some people recognized the fiscal importance of the shad population in the river, and during the shad season, regulated by the legislature, shad fisheries operated along the Gloucester riverfront either by the local landowners or those who rented the fishing grounds. The town also served as a retreat for pleasure-seekers from Philadelphia.

David Brown was working in Philadelphia when he visited Gloucestertown. Brown saw potential in all the undeveloped land along the Delaware River. He purchased the 107-acre Ellis farm and the 300-acre Harrison farm. In 1845, Brown built Washington Mills, which drew many people to the town for employment. Soon after opening the mill, Brown built the Ancona Printing Company, which brought more people to the town. He also formed the Gloucester Land Company, which sold lots to factory employees and those store owners wanting to build accommodations to serve the workers. The land company also laid out streets, making Gloucester a viable community. By the 1880s, a second mill was constructed along with an ironworks, terra-cotta works, and gasworks. Brown had brought about the rise of modern Gloucester City.

In 1869, Gloucester was incorporated as a city. This led to the construction of a new city hall structure and organization of a police force. Due to a devastating fire because of no means to fight it, the city created a fire department in 1875. In 1883, it was determined that a waterworks would be constructed to provide its residents with water. At the time of its construction, the water plant was the third municipally operated waterworks in the country. The original building still sits on the grounds of the water department. This building is the only city-owned structure in town that is in the National Register of Historic Places.

In 1870, William Thompson, "the Duke," arrived in Gloucester City. Upon seeing the city's potential, Thompson leased the Buena Vista Hotel. It was here that he learned of the local tradition of serving planked shad dinners. Thompson was not only a shrewd businessman but also a great politician. As a politically minded person, he opened a racetrack for horses in 1890. The opening of the racetrack brought record crowds to the city. Soon, saloons and gambling houses were found throughout the town. This attracted many Philadelphians to some "sinful" weekends away from home. The Duke persuaded many highly placed political figures of the time to visit Gloucester City. On any given weekend, one could see various politicians from across the country in town. By 1893, the state legislature passed the law that prohibited bookmaking, and the racetrack closed. The city still stayed relatively popular due to the surrounding towns' blue laws; it was still legal to serve alcohol on Sundays in Gloucester City.

The 20th century brought more prosperity to the city, with its ideal location along the Delaware River. This was why the first Native Americans and the Dutch picked this location for their settlements. The city became home to some major industrial companies, like Pusey and Jones Shipbuilding, Welsbach Mantles, Armstrong Cork, GAF Building Materials Company, and New York Shipbuilding. The large waterfront industry helped the growth of the city through the first half of the 20th century, and a large portion of its population relied on employment in the factories. As in most of the United States, the second half of the 20th century saw major drops in industrial and manufacturing production. Most of Gloucester City's waterfront industry has disappeared, and the area is waiting for another rebirth. The future of the city still relies on its location along the Delaware River.

The Gloucester City Historical Society has been collecting and preserving the city's past since 1917. Many of the photographs in this book come from the society's collections. Other photographs come from private collections, some of which have just opened up for the first time. It was our goal to give a brief photographic history of the city for everyone to enjoy.

One

SETTLEMENT TO RESORT

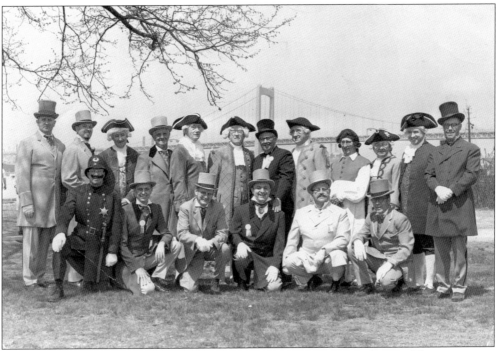

The city of Gloucester has gone through many transformations in its history. The town was a basic settlement on the Delaware River until 1686, when it was made the county seat. Gloucester prospered for 100 years but quickly declined after the county seat was relocated to the town of Woodbury. Then, Gloucester was just a small village along the Delaware River until 1844, when a rebirth occurred in the form of industry. Once industry arrived, the town found itself in need of homes and businesses. New residents also needed forms of entrainment, thus horse racing and amusement parks were a part of the local changes. Although some of the factories changed names and products through the years, the demand for blue-collar workers continued into the 20th century. Since colonial times, one of the largest traditions still to occur each year is the meeting of the New Jersey proprietors. Each May, since 1688, the West Jersey proprietors have met at the Delaware River in Gloucester City in order to agree on the boundary line of West Jersey. The image above of the proprietors was taken in 1969. Those pictured are, from left to right, (first row) William Kensler, James L. Joiner, Francis J. Gorman, Fredrick C. Anzide, Edgar Kniceley, and William Gartland; (second row) Thomas J. Kilcorse, Thomas L. Schaeffer, Ralph Black, Joseph Sheriden, Albert J. Corcoran, Harry F. Green, Mayor Vincent M. Daily, Louis A. Kelly, Ernest F. Uibel, Ernest E. Unger, John R. Murray, and Gloucester City solicitor William E. Hughes. (Courtesy of the Gloucester City Democrat Club.)

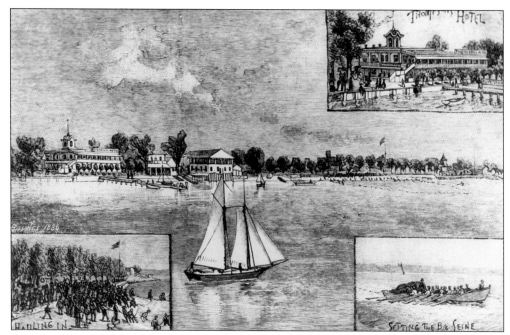

Since its first settlement, the waterfront has attracted people to Gloucester City. The city has been an early colonial settlement, a small village, a resort destination, and an industrial port. This graphic is believed to be a place mat that was used at the Thompson Hotel.

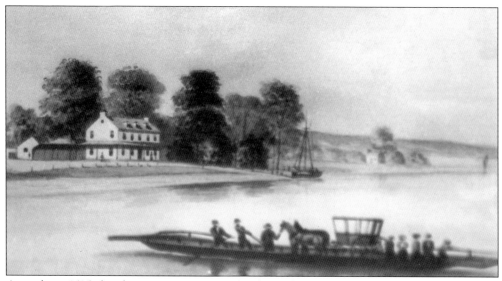

As early as 1695, ferryboats were operating on the Delaware River to bring products, people, and animals across the river from Philadelphia. This drawing shows an early man-powered ferry, called a wherry.

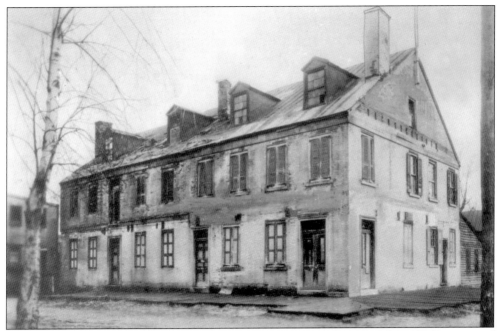

Joseph Hugg built Hugg's Tavern in 1721–1722. The tavern was the site of the early formation of Gloucester County. Built near the new courthouse, it served for many years as the center of political, legal, and social activities in the area. One of the noteworthy events at the historic structure was the marriage of John Ross to Elizabeth Griscom. She later became known as Betsy Ross, said to have created the American flag. (Courtesy of the Gloucester County Historical Society.)

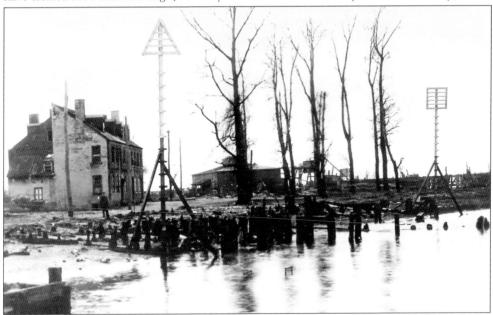

Seen here, Hugg's Tavern is awaiting its demolition. Camden County razed the building and the surrounding structures in order to build a park. At one time, the tavern also housed the Philadelphia Fox Hunting Club. The livery can be seen in the center of the photograph. (Courtesy of the Gloucester County Historical Society.)

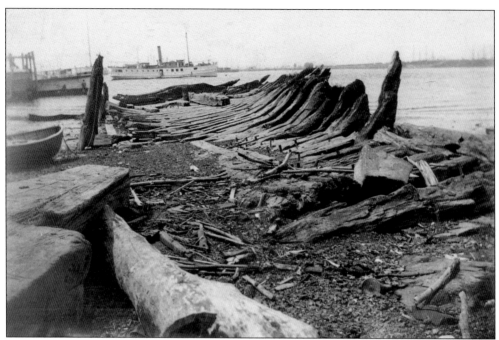

The British warship *Augusta* was built in 1763. The vessel's only war service was at the Battle of Red Bank in 1777, when the ship was burned and grounded. The *Augusta* was later hoisted up from the depths and towed upriver on its way to be exhibited at the centennial exposition in Philadelphia. Unable to reach its destination, it was beached at Gloucester City. A hole was cut in the side, and the ship was used as a museum. The remains of the hull can be seen here.

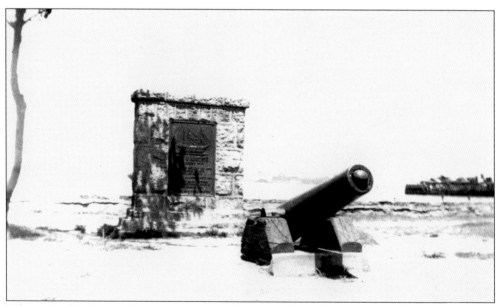

When Camden County Park was created in Gloucester City, a plaque was placed commemorating the location where the *Augusta* beached. One of the ship's cannons was stationed in the park for years until it disappeared. Many of the residents in the area have pieces of the remains of the oak hull; these were typically carved into souvenirs. (Courtesy of the Harry Demarest collection.)

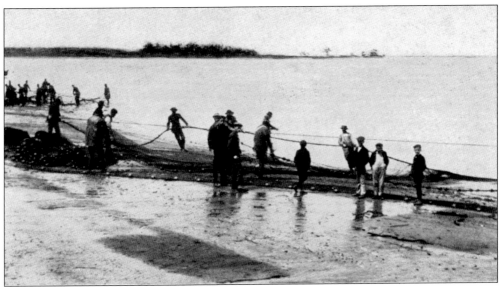

Shad fishing up and down the Delaware River was a lucrative industry. Several fisheries were located in the area. The industry was at an all-time high in the 1880s. During the 1890s, Gloucester City's main attraction was planked shad dinners, which would bring locals and Philadelphians to in for the fine-dining atmosphere. (Courtesy of Ed Walens.)

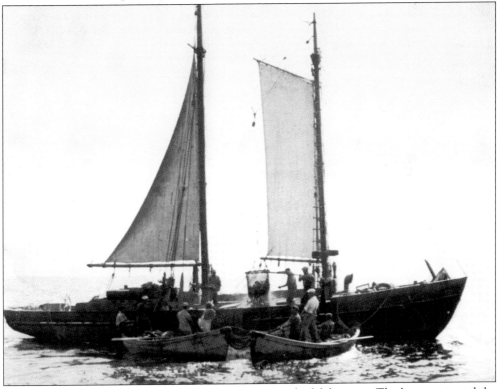

The schooner *Fishhawk* was responsible for monitoring shad fisherman. The boat navigated the Delaware River and periodically checked the fishing trawlers to make sure operations were being followed per the laws of the time. (Courtesy of VFW Museum Post 3620.)

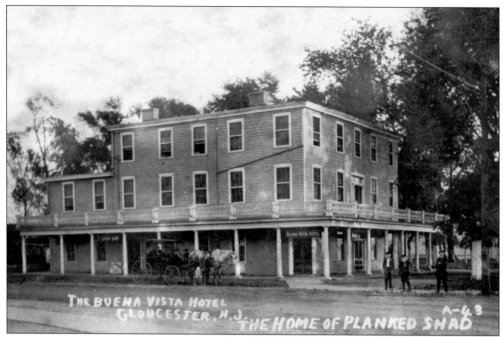

In 1870, William Thompson leased the Buena Vista Hotel, which was built around 1849. The hotel was located at the southwest corner of King Street and Jersey Avenue, adjacent to the ferry dock. It was here that Thompson began the local tradition of planked shad dinners. (Courtesy of the Harry Demarest collection.)

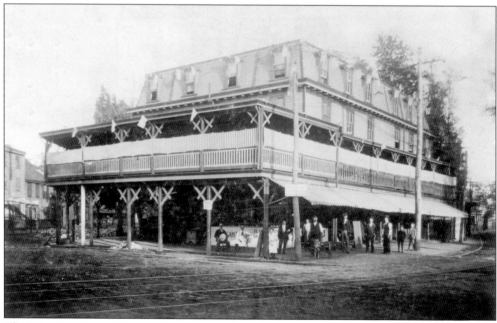

The Mansion House Hotel was constructed in the 1850s at the southeastern corner of King Street and Jersey Avenue. The hotel was located just across from the ferry-terminal docks. James McGlade was the proprietor of the hotel, which was renowned for its excellent accommodations and high-class service. (Courtesy of Bill and Dianne Fisher.)

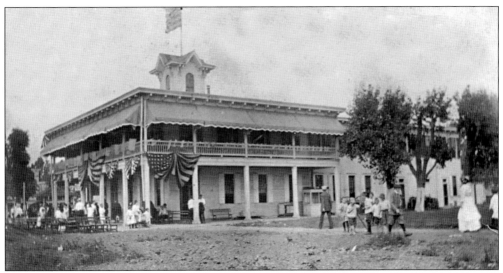

After William Thompson's lease expired on the Buena Vista Hotel, he invested in his own business. Thompson's Hotel was located at end of Third Street at the Delaware River. The hotel's main competition was the Buena Vista Hotel. Thompson was good at persuading people to come to the town and brought record crowds of visitors to Gloucester City. (Courtesy of Shad Agar.)

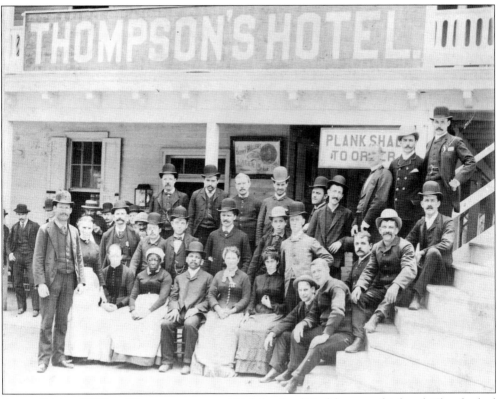

As a politician, William Thompson attracted high-level political figures to his hotel. The planked shad dinners became famous along the East Coast, and on any given night, one could see various politicians in the Thompson Hotel dining room feasting on shad. (Courtesy of Shad Agar.)

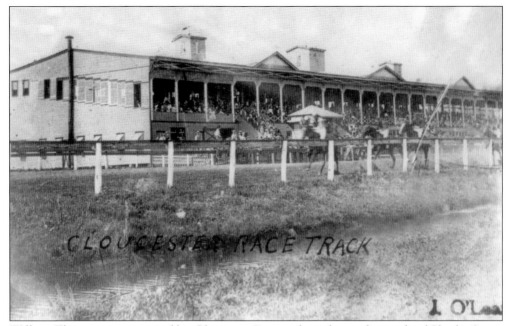

William Thompson constructed his Gloucester Racetrack on the southern side of Charles Street in 1890. The grandstand could accommodate over 5,000 spectators, and the interior field could hold up to 400 horses. The track closed on Thanksgiving 1893, due to statewide legislation prohibiting gambling. (Courtesy of VFW Museum Post 3620.)

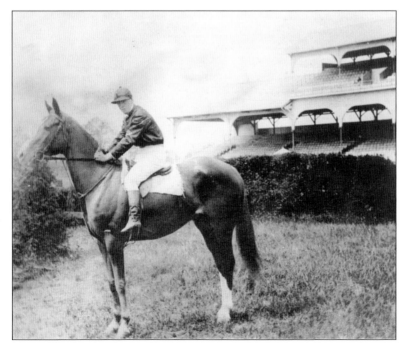

Belsarus was one of the horses who raced at the Gloucester Racetrack during the 1892 season. Frank Wier and Dick Little owned the horse, and an unidentified jockey is seen on the steed.

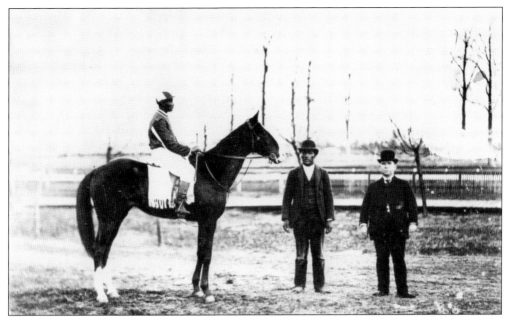

This 1892 photograph shows the horse Mary B. with jockey Morris Up. The man in the middle is John Butts, who was William Thompson's houseman, and to the right is Mayor John Boylan. Thompson profited very well from the racetrack, which was in operation for only three years. Ferries and trolley lines brought local spectators to the track, and Thompson controlled these transportation systems as well. (Courtesy of the T.E. Williams collection.)

One of the most famous ponies was a horse named Sunday. The animal was born on a Sunday, won his first race on Sunday, and ironically, died on a Sunday. In order to honor Sunday, he was buried in the home stretch of Gloucester Racetrack. (Courtesy of the Louisa Llewellyn collection.)

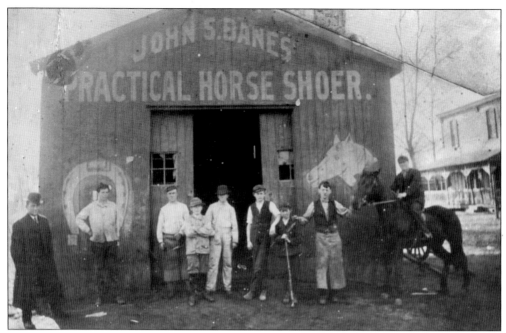

Many stabling, horseshoeing, and blacksmithing enterprises sprang up to tend to the business of caring for the horses, which were also used as the main mode of transportation. This is Johnie Banes's blacksmith shop, which was located at the corner of Fifth Street and Jersey Avenue. (Courtesy of the Harry Demarest collection.)

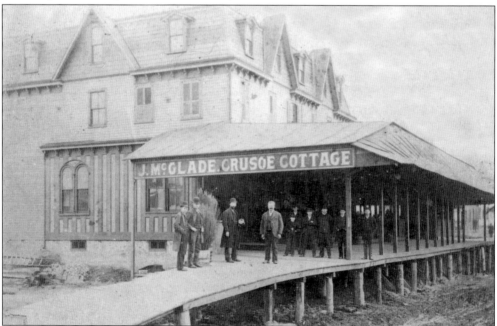

With a local racetrack planned, James McGlade saw an opportunity for more growth. In 1889, McGlade had a hotel built at the corner of Sixth and Charles Streets, located near the racetrack site. The business became known as the Crusoe Cottage, which specialized in catering to the gambling crowd. This photograph was taken in 1892. (Courtesy of Shad Agar.)

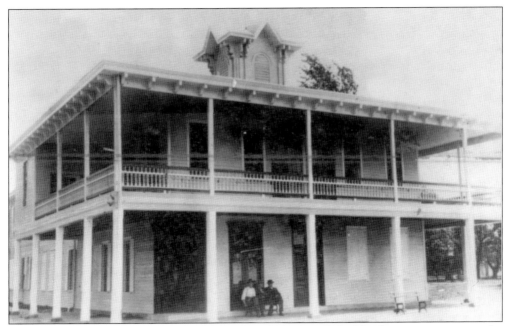

After the racetrack closed down in 1893, Billy Thompson shifted his business interest to the nearby town of West Deptford. In that location, Thompson constructed Washington Park, an amusement park. He kept his hotel open; however, when attendance shifted further south, he decided to close the lodging. In 1923, the old Thompson Hotel became a community building; Mayor McNally gifted it to the city. (Courtesy of Bill and Dianne Fisher.)

The other, smaller hotels seemed to survive for a while since these businesses catered to visitors who wished to visit Gloucester's beachfront. In 1895, Hotel Kilcourse was located on Third Street and Jersey Avenue and was operated by George W. Lancaster. The business survived into the early part of the 20th century.

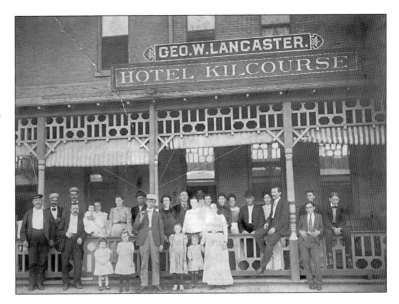

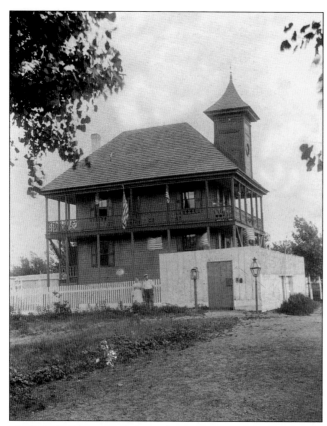

Another place that was created due to the racing industry in Gloucester City was the South Jersey Jockey Club. The building long survived the demise of the racetrack. The structure was converted into a home and remained a residence until it burned down in a fire in the 1920s. (Courtesy of Ed Walens.)

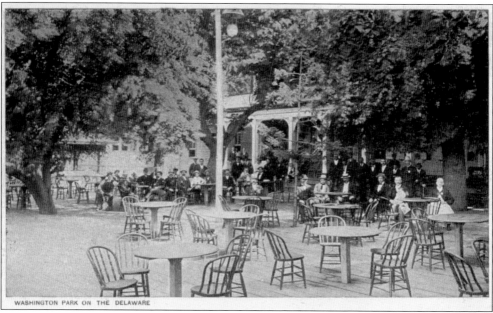

WASHINGTON PARK ON THE DELAWARE

Washington Park was built by William Thompson in nearby West Deptford. This postcard shows the café and restaurant located on the grounds. Thompson built the park on the Howell estate, the main house of which can be seen in the background. (Courtesy of the Martorano family.)

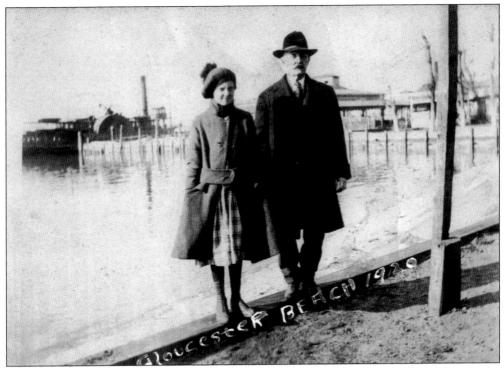

Laura and Steve Emery are standing along the bulkhead at the Gloucester City beachfront in the 1920s. Throughout the first half of the 20th century, most of the resort areas disappeared in order to make way for industries and their employees. (Courtesy of VFW Museum Post 3620.)

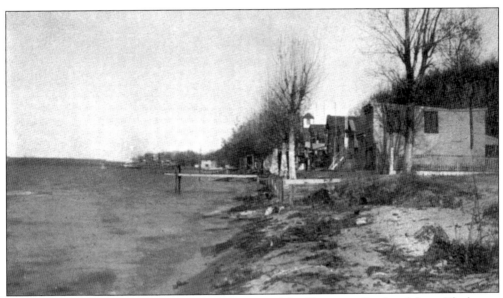

Looking north from Little Timber Creek, this view is of the Gloucester City beachfront. The homes to the right were small fishing shanties, making up an area known as "Hollywood." These homes were later torn down to make way for a county park. (Courtesy of the Martorano family.)

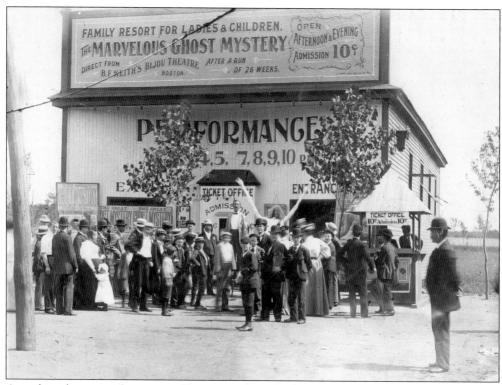

As early as the racetrack years, an effort was made to develop more of the beachfront. A bandstand was built along with various amusements to create another destination in the city. In this 1898 image is the theater building that was constructed to lure crowds to enjoy daily performances. (Courtesy of the Albert Corcoran collection.)

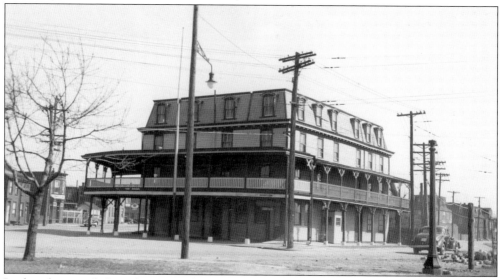

In this photograph from the 1940s, the Mansion House Hotel has not changed very much over time from the original building, seen on page 14. Despite a fire in the 1970s, parts of the original structure are still present. This is one of the last surviving buildings from the city's resort years. (Courtesy of Bill and Dianne Fisher.)

Two

CHURCHES

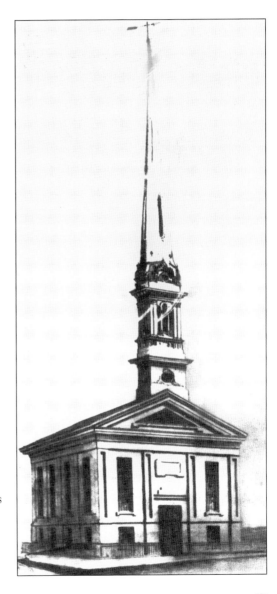

Religion in the town of Gloucester dates back to the days of Rev. Nathaniel Evans preaching in areas of present-day Gloucester City and Cherry Hill. The image seen here is a rendering of what the Presbyterian church looked like when it was first constructed in the city. The steeple was 83 feet tall, but in 1853, a cyclone blew it down. Wood recovered from the steeple was later used to build a birdhouse at the Crocker Cottage (seen on page 51).

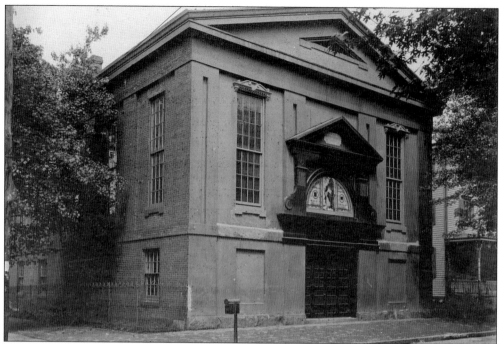

As far back as 1847, a Presbyterian clergyman held services at Washington Hall, which was the birthplace of most of the congregations in town. On October 11, 1848, the cornerstone was laid for the First Presbyterian Church on Monmouth Street. The stained-glass windows had not been installed at the time this photograph was taken. (Courtesy of Shad Agar.)

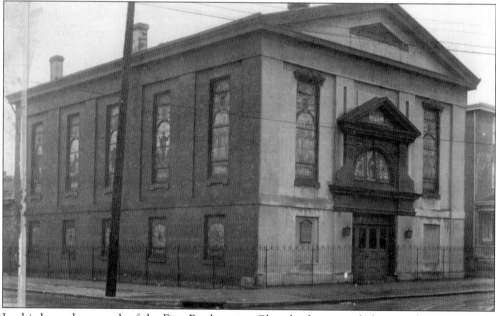

In this later photograph of the First Presbyterian Church, the stained-glass windows are clearly in place. The original cost to build this structure was $8,000. In 1870, a parsonage was built next to this church. The first reverend to reside and preach at the church was Henry M. Reeyes. (Courtesy of VFW Museum Post 3620.)

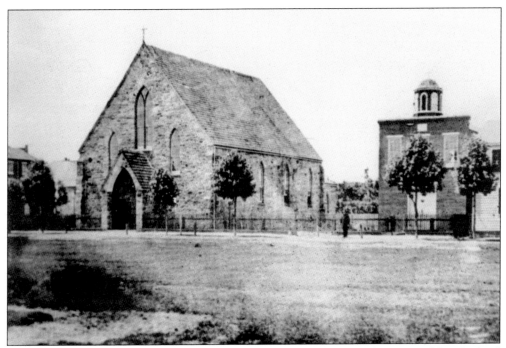

The original St. Mary's Church was constructed in 1849 at the corner of Sussex and Cumberland Streets. The building had a seating capacity of 400. As the number of Catholic parishioners increased, so did the need to build a larger church for them in Gloucester.

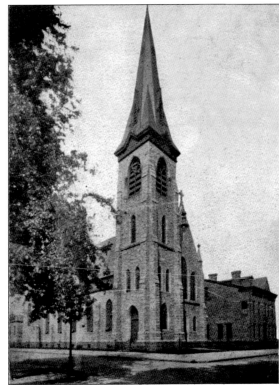

On March 24, 1888, the congregation broke ground for a new church. The location was Monmouth and Atlantic Streets. The new structure was completed by November 1889 at a total cost of $65,000. The style of architecture of the church is known as Gothic Revival. The 160-foot-tall steeple contains 10 bells within the tower that chime hourly. (Courtesy of Linda Locker.)

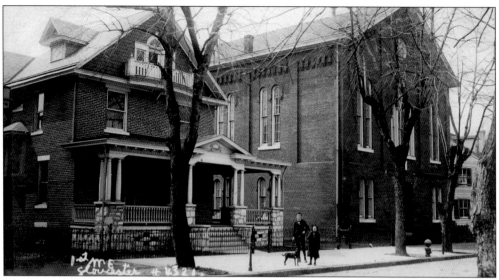

The First Methodist Episcopal Church originated in 1838 when the members built a chapel on Market Street. In 1850, a frame building was constructed at Monmouth and Willow Streets. A year later, a brick parsonage was built to the east side of the church for the clergyman to reside in. (Courtesy of Linda Locker.)

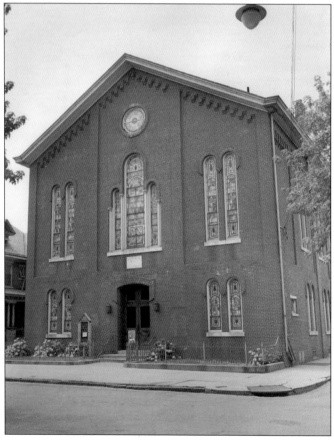

Parishioners held services here until December 1882, when a fire destroyed the structure. The church was quickly rebuilt at a cost of $14,000. The building was sold in the 1990s and is now a private residence. (Courtesy of the Funk family collection.)

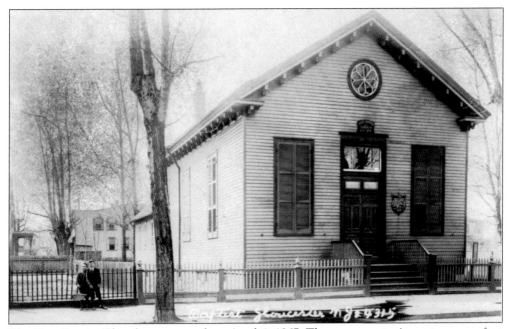

The First Baptist Church was created on April 4, 1867. The congregation's services were first held at Washington Hall, until this frame meetinghouse was constructed. The new church was located at the corner of Monmouth and Sussex Streets and could accommodate up to 300 people. (Courtesy of VFW Museum Post 3620.)

The first pastor of the First Baptist Church was E.C. Parker, and increasing attendance meant that a larger structure was needed. The current church was built in 1913 at the location of the original church at the corner of Monmouth and Sussex Streets. (Courtesy of the Funk family collection.)

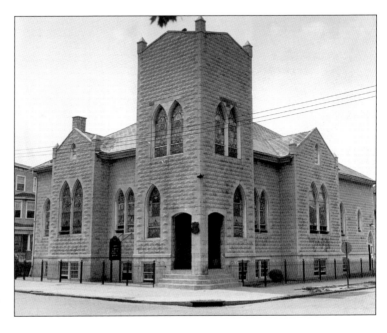

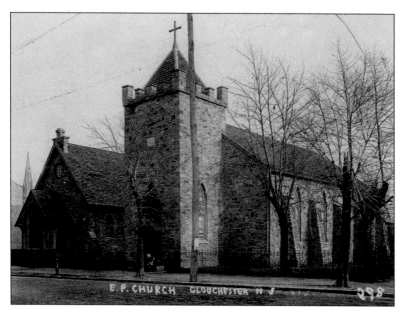

The Church of the Ascension was organized in 1847 through the efforts of Rev. Isaac Labaugh of Haddonfield. A plot of land on Sussex and Ridgeway Streets was donated to the congregation. In 1849, this stone church was erected with a seating capacity of 350. (Courtesy of VFW Museum Post 3620.)

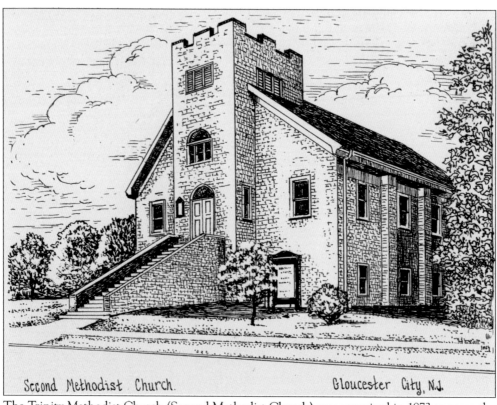

Second Methodist Church. Gloucester City, N.J.

The Trinity Methodist Church (Second Methodist Church) was organized in 1873 to serve the Pine Grove section of Gloucester City. With Rev. Anthony King as preacher, the first church building was finished in 1885. By 1927, a new, larger church (pictured) was erected at Eighth and Division Streets. (Courtesy of the Earle Nazar collection.)

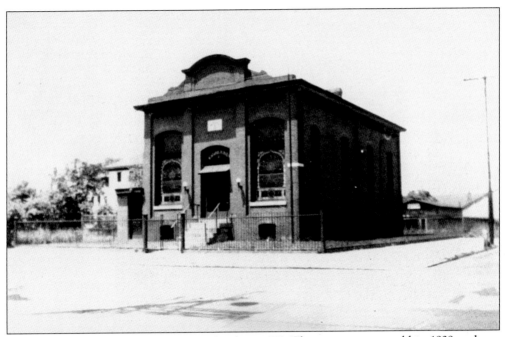

Security Trust Company was built as a bank in 1873. The structure was sold in 1939 and was converted into Beth El Synagogue. Charlie Goodman and many other Jewish business owners needed a place of their own in town to worship. The building operated as a synagogue until 1983. Currently, the structure operates as a tavern. (Courtesy of the Harry Demarest collection.)

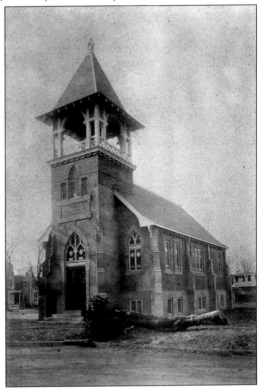

Bethany Evangelical Lutheran Church was founded in 1905. By December 1908, the current structure was built and services could be heard in both English and German. The same bell has been handing in the tower since 1935. It was purchased from the school board and was formerly located in the tower at the original Monmouth Street School. This congregation lasted until 1997, when low attendance led to the church closing. Today, the building has been converted into a private residence. (Courtesy of the Bethany Lutheran Church collection.)

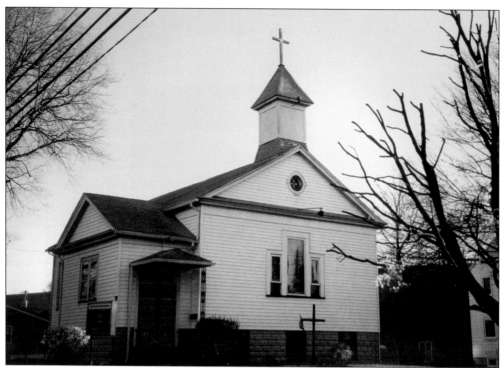

Rev. Richard Conover organized the Highland Park Methodist Church in 1919. The church building was later constructed in the 1920s. The Methodist church is located on Highland Boulevard and still serves this section of Gloucester City today. (Courtesy of Gloucester City.)

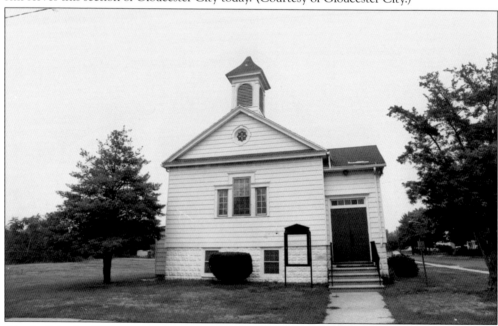

Also built in the 1920s at a cost of $6,015 was the Gloucester Heights Church. The church served a Methodist congregation in Gloucester Heights, led by Rev. William Harker before it was closed down. Today, it is the Church of the Risen King. (Courtesy of Gloucester City.)

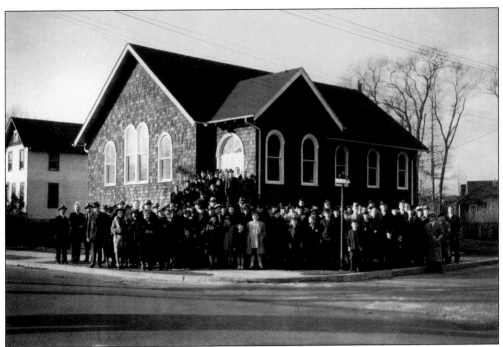

The Church of God can trace its origins back to the workings of Rev. Herbert Huntsinger. Huntsinger was the reverend of the first religious service held in Gloucester in 1914. Until a church was founded, the first few services were held in peoples' homes. In 1916, the congregation secured a shoemaker's shop at 228 Burlington Street. By 1932, attendance had grown to merit a larger place for worship. The new church was located at Baynes Avenue and Market Street and was completed in 1935. The above image is the original church. In 1965, it was enlarged and modernized, as shown in the photograph below. (Above, courtesy of VFW Museum Post 3620; below, courtesy of Gloucester City.)

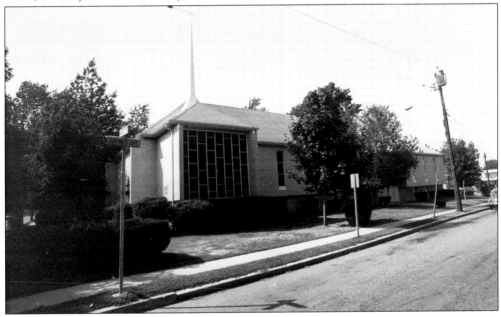

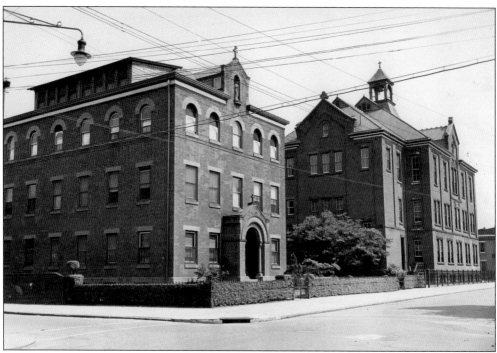

The building at the corner of Ridgeway and Sussex Streets was the convent of the Dominican Sisters operating St. Mary's School. Today, the building is used by Gloucester Catholic High School. (Courtesy of the Funk family collection.)

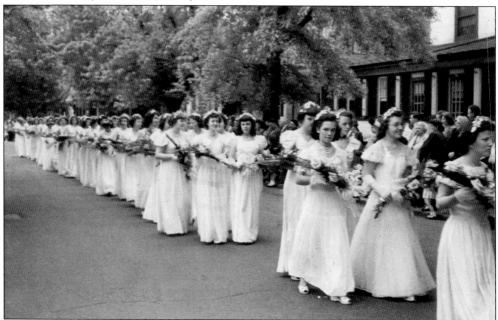

At the end of each school year, St. Mary's School and Church would hold an annual procession. The female students would wear their finest dresses and parade down Monmouth Street to St. Mary's Church in honor of the Blessed Mother. The girls would place flowers at the church. (Courtesy of Anna May Nacella.)

Three

SCHOOLS

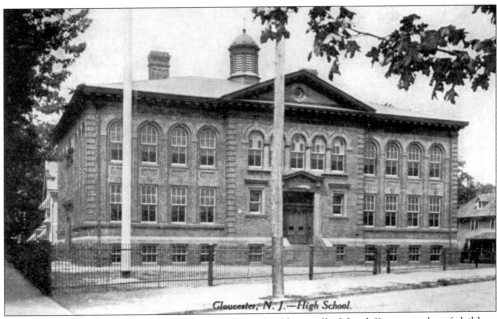

Gloucester, N. J.—High School.

Gloucester City's first school was a one-room frame building. All of the different grades of children were taught their school lessons in a single room. In 1869, the Ridgeway School was constructed at a cost of $5,000. During the early years, the teachers could earn anywhere from $450 to $500 a year as a salary for their educational services. Pictured is Gloucester High School in 1915. The building later became the Monmouth Street School. (Courtesy of the Parent family.)

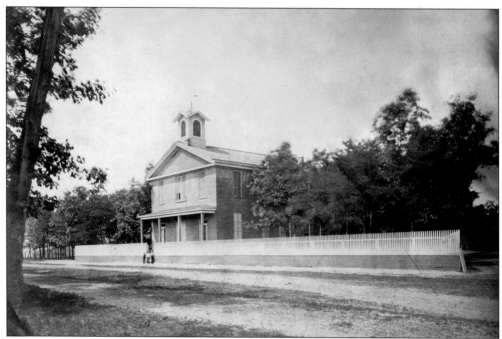

Designed by Camden architect Stephen Decatur Button, this building was constructed in 1859 at a cost of $7,000. The Monmouth Street School was the first two-story schoolhouse in the city. The school was located just off Broadway and became the town's first high school. It survived until 1907, when it was replaced by a larger structure. (Courtesy of the Harry Green collection.)

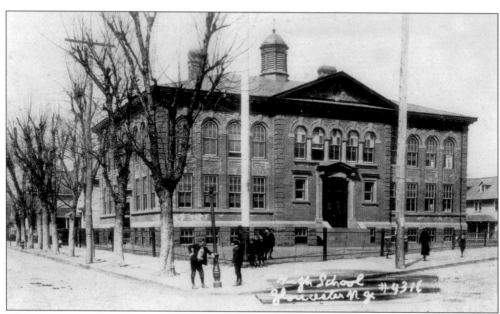

This 1910 photograph shows the second high school building, located at Broadway and Monmouth Street. The people standing at the light pole are Archie Grey (left) and Baile Hetherington. This building was constructed in 1907 in the place of the original Monmouth Street School. (Courtesy of VFW Museum Post 3620.)

The Powell Street School was at the corner of Barnard Avenue and Powell Street. This structure is another of the one-room schoolhouses. The school was used until the 1930s and demolished in 1939.

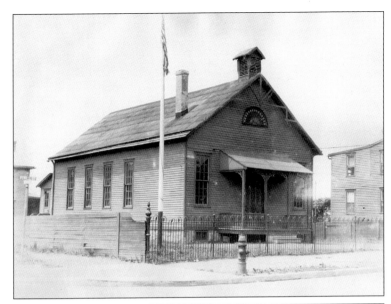

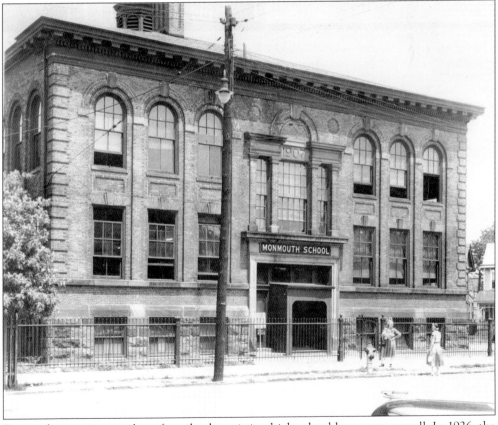

Due to the growing number of pupils, the existing high school became too small. In 1926, the old high school building became the Monmouth Street School. The structure continued to be used for educational purposes until it was destroyed by fire in 1960. (Courtesy of VFW Museum Post 3620.)

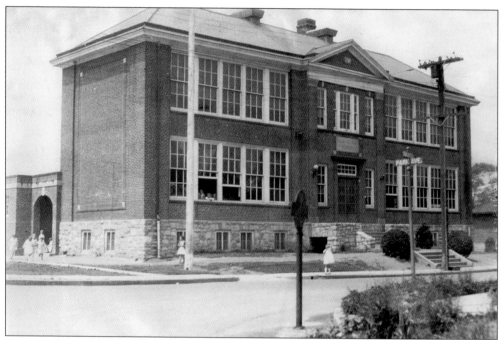

The Highland Park School was built in 1915. This facility handled schoolchildren from the city's eastern section. The school is located at Highland Boulevard and Park Avenue. The building currently houses an adult continuing education program and an alternative high school.

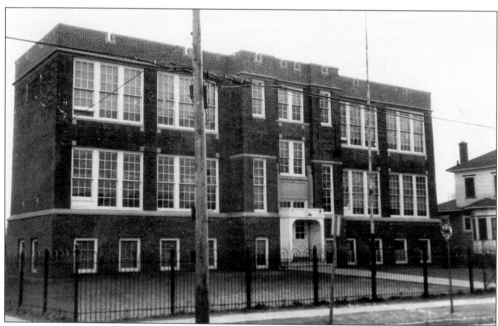

The Gloucester Heights School is located on Nicholson Road and served the local children who lived in this section of the city. Constructed in 1915 by the township of Haddon, it was used as an educational facility until the 1990s. The building is now used by a private book depository business. (Courtesy of Gloucester City.)

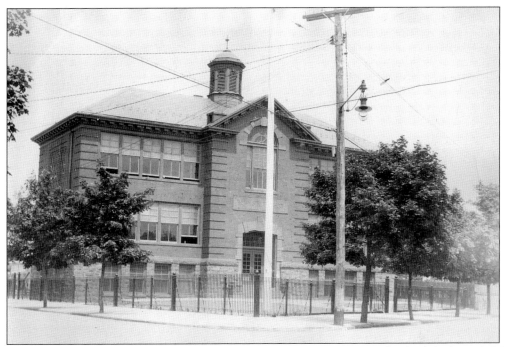

Located at the corner of Brown and Somerset Streets, the Brown Street School was built in 1915. This structure was also used as a neighborhood school. The Police Athletic League now owns the building. Today, it is the venue for many events for after-school programs and also the home of local public-access channel 19.

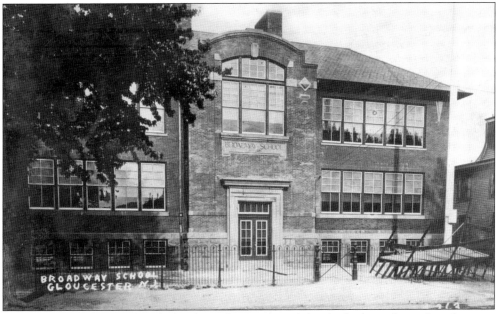

In 1915, another neighborhood school was the Broadway School, which was located on the main business corridor between Mercer and Middlesex Streets. The school served city children until the 1990s, when it was sold. The structure is currently used as an office building. (Courtesy of the Louisa Llewellyn collection.)

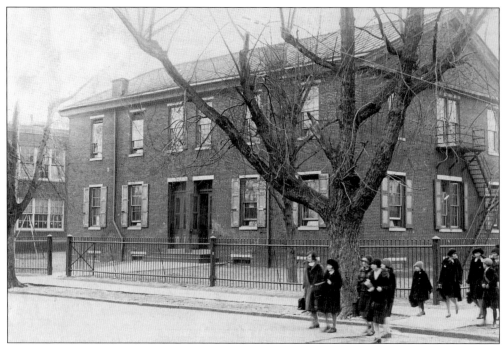

The two-story Cumberland Street School was built in 1868 and faced Joy Street. It was demolished in the 1920s to make way for the new high school. (Courtesy of the Oliver Stetser collection.)

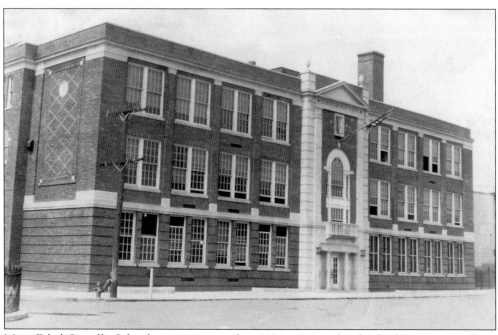

Mary Ethel Costello School was constructed in 1926–1927 as the third Gloucester City high school. This school now operates as an elementary school at the corner of Cumberland and Joy Streets. The building also houses the Gloucester City Board of Education Offices. (Courtesy of the Harry Demarest collection.)

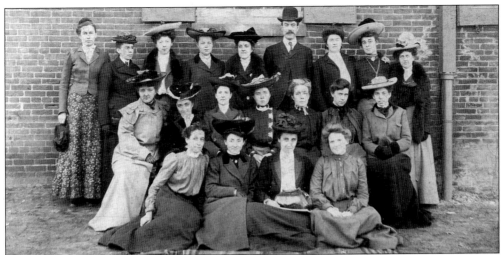

A photograph of the teachers at Gloucester Public School in 1907 includes, from left to right, (first row) Louise Powell, Eva Harris, Sue Roe, and Helen Cheeseman (Fray); (second row) Rose McBride, Delma Gardner, Susan Norcross, Christine O'Hara (Barnard), Mary Whittington, Olive Stringer (Baisel), and Elizabeth McCullough; (third row) Annie Magill, May Husted, Kathryn Cramer (Kandel), Helen Barnard (Craig), Florence Collings (Vickers), superintendent William Sullivan, Mary Gordon (Carey), Elizabeth Dermott (Eckels), and Laura Ogden (Clymar).

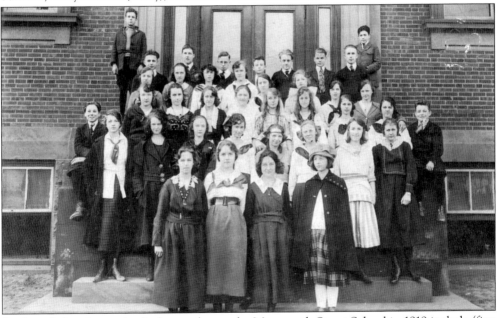

Students belonging to the freshman class at the Monmouth Street School in 1919 include (first row) Amethyst Wickham, Orrie Thompson, Corona Halliwell, and Ernestine Anderson; (second row) Edna Rambo, Florence Ellis, Addie Pervis, Mary Thorp, Alta Powell, Elizabeth Theckston, and Ada Morgan; (third row) Helen McGunagle, Julia Hughes, Mary Morton, Ursella Parsons, Blanche Munn, Martha Powell, Louie Rohrbacher, Dorothy Adams, and Emily Lee; (fourth row) Sylvia Oxley, Ella McDougal, Bessie Thatcher, Mildred Ledden, and Bernice Pollitt; (fifth row) Harry Demarest, George Daily, Tom Ross, Ernest Thompson, Lynn Gongloff, Walt Munn, and Norman Godshall. (Courtesy of the Harry Green collection.)

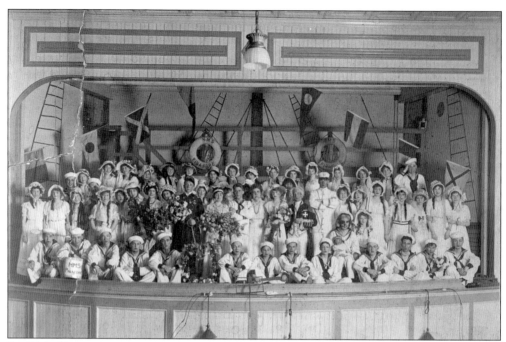

In 1916, Gloucester City High School did a production of a Gilbert and Sullivan operetta, *H.M.S. Pinafore*. The play was directed by Miss G. Baker. (Courtesy of the Albert Corcoran collection.)

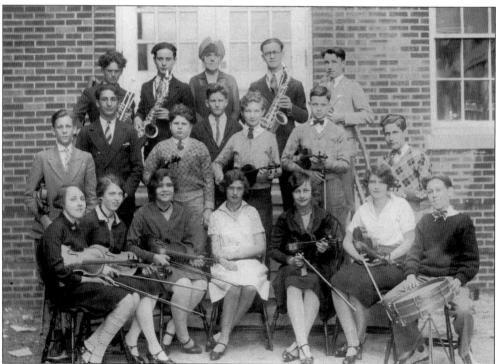

This 1928 photograph shows the Gloucester City High School Orchestra. (Courtesy of VFW Museum Post 3620.)

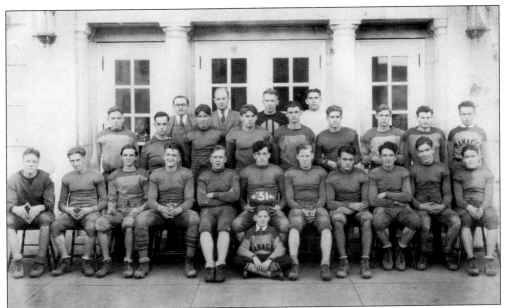

The 1931 Gloucester City High School football team poses for a picture in front of the old high school building. Through the years, the high school had successful teams that won several championships. Nearly everyone in town looks forward to the city championship game between Gloucester Catholic and Gloucester City high schools. (Courtesy of VFW Museum Post 3620.)

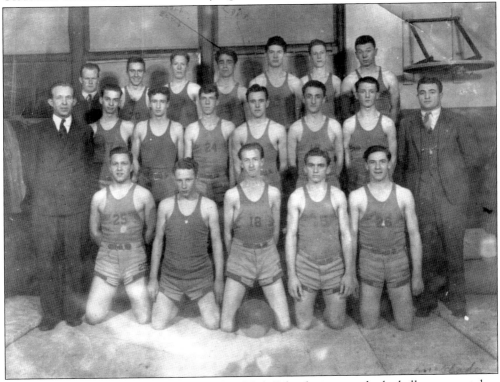

This picture of the 1937–1938 Gloucester City High School tri-county basketball team was taken in the school's gymnasium. (Courtesy of VFW Museum Post 3620.)

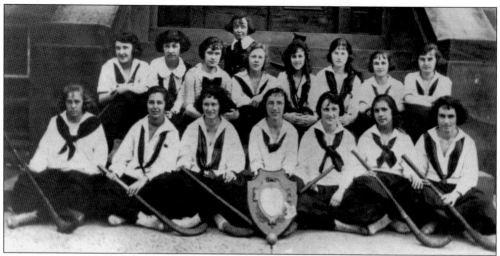

This photograph of the 1922 championship field hockey team for Gloucester City High School includes coach Bessie Taylor, Helen McGonigle, Alice Donaldson, Bessie Thatcher, Alta Powell, Martha Powell, Clara Alhouse, Mary Powell, Barbara Alhouse, Sue Pierce, Amethyst Wickham, Adelaide Burrows, Elizabeth Theckston, Irene Dennery, Sadie Alexander, and Julie Hughes. The photograph was taken when the high school located at the corner of Broadway and Monmouth Street. (Courtesy of the Harry Demarest collection.)

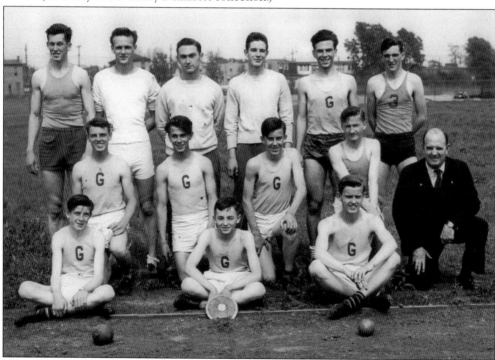

Track and field was another activity that local students enjoyed. This is a Gloucester City High School track team after World War II. Those pictured are, from left to right, (first row) unidentified, Bill James, and Otis Smith; (second row) Don Hammer, Joe Levingood, Jack Dickson, unidentified, and coach Harry Demarest; (third row) Joe Garvey, Gunner Ashburn, Herb Zane, Tennessee Smith, Charles Aldrich, and unidentified. (Courtesy of the Harry Demarest collection.)

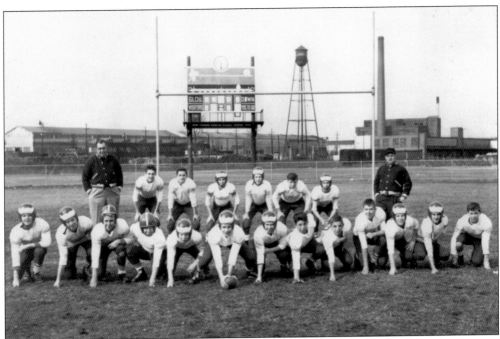

Before the new high school was constructed, most of the high school and youth sporting events occurred at Cold Springs Field or the Charles Street Stadium. This is the Mustang junior varsity football team sometime in the 1950s. In the background is evidence that Charles Street Stadium was located in the industrial section of the city. (Courtesy of VFW Museum Post 3620.)

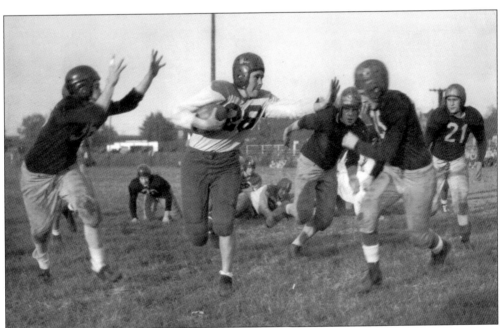

Players in the 1950s actually used real pigskin footballs and wore leather helmets and padding. Take notice of the lack of safety gear, which is in great contrast to today's players covered in safety padding and modern equipment. (Courtesy of VFW Museum Post 3620.)

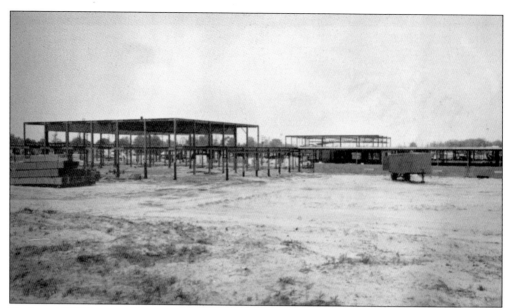

By the mid-1950s, a need for a new public high school was a great concern. The ground-breaking for the new school facilities was in 1959. The school was located at Crescent Boulevard (Route 130) and Market Street. This photograph from April 1960 shows the steel framework of the new structure.

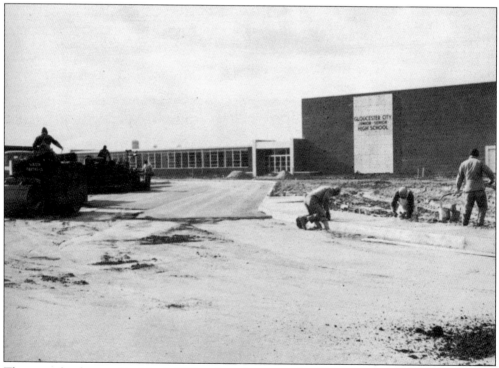

The new school opened in March 1961 and was known as the Gloucester City Junior-Senior High School. Over the years, the school has seen some expansions in order to facilitate more room for students. To this day, the school houses grades 7 through 12.

As far back as the mid-1800s, the Roman Catholic school of St. Mary's provided education to local children. St. Mary's Grammar School was built at the corner of Sussex and Cumberland Streets in 1893. This site was the original location of St. Mary's Church before it was moved to Monmouth Street. (Courtesy of Linda Locker.)

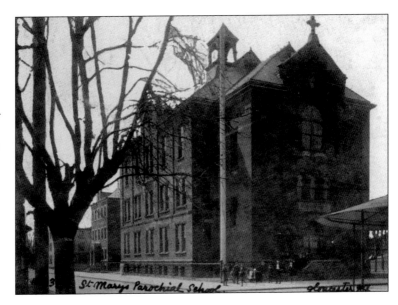

Once attendance increased at the grammar school, the Catholic diocese saw the need to expand the size of the school system. St. Mary's High School was located at the corner of Burlington and Monmouth Streets. This building was added onto the Berryman mansion. The house served as the home of Henry West, superintendent of Washington Mills. The structure is now the annex of Gloucester Catholic's campus. (Courtesy of Ed Walens.)

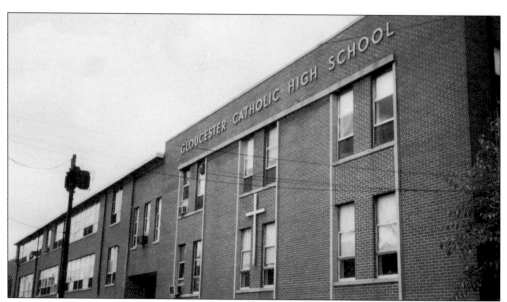

The student body of Gloucester Catholic School was growing quickly, so a new building on Cumberland Street was constructed in 1949. In the 1960s, due to an influx of students, another addition was made. This school attracts not only city residents but students from many families from South Jersey. (Courtesy of Ed Walens.)

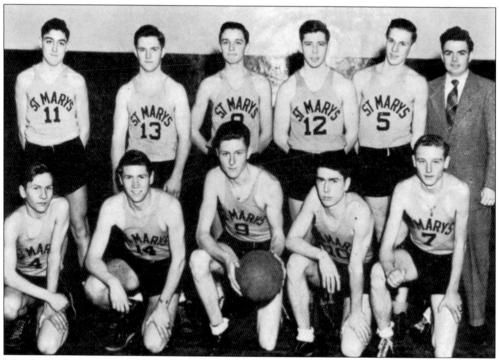

Members of St. Mary's varsity basketball team of 1946 include, from left to right, (kneeling) James Devereaux, Thomas Breslin, captain Francis Headley, Charles Web, and Jerry Sampson; (standing) Thomas Gardner, Patrick Flynn, Henry Murphy, Charles Boyle, William Bernard, and manager Thomas Nolan.

Four

HISTORIC HOMES
AND STREETSCAPES

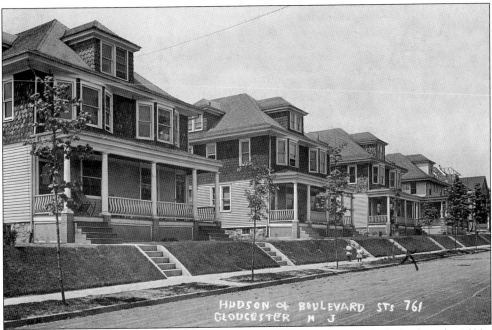

Through the years, Gloucester City has seen its share of historic homes. As far back as the 1600s, there were farmhouses built in order for the locals to tend the land. Along with the population of Gloucester City and industry, the need for housing grew. Many of the city's historic structures have been demolished to make way for progress, but a few such homes still stand. This photograph shows the 900 block of Hudson Street. This section of the city was known as the Monmouth Terrace. At the far right side of the picture, a worker framing the roof of a house is visible. (Courtesy of the Parent family.)

This image was taken in 1890 and shows the Sheriff West home, located at the southwest corner of Broadway and Monmouth Street. Today, this building still stands and houses the municipal offices for the city, including the clerk's office, tax office, and mayor's office. (Courtesy of Bill and Dianne Fisher.)

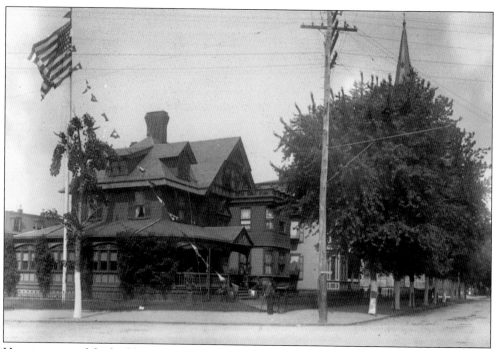

Here is a view of the building 20 years later in 1910. Take notice of the two-story addition out of the gable end of home and the now enclosed porch. Besides being used for municipal offices, the building has been the public library, the veterans assistance office, and a baby keep-well station. (Courtesy of Bill and Dianne Fisher.)

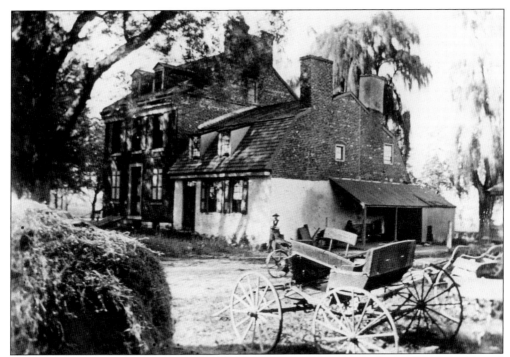

Harrison Manor was one of the homes from Gloucester City's colonial period and was located at the northeast corner of Brown and Mercer Streets. Originally constructed in the 1720s, it replaced a frame structure built by the William Hunt family. A 1756 addition by the Harrison family is seen in the photograph above. Harrison's farm covered over 300 acres of land. As the town grew, it was just a matter of time until the farm was sold off to create streets and housing parcels. Harrison Manor was torn town in 1941, and many residents were sorry to see its demolition. (Above, courtesy of the Harry Demarest collection.)

The original Harrison homestead was located in the area of the present-day library. This house was constructed before 1700. The home was razed to make room for the Gaunt farmhouse.

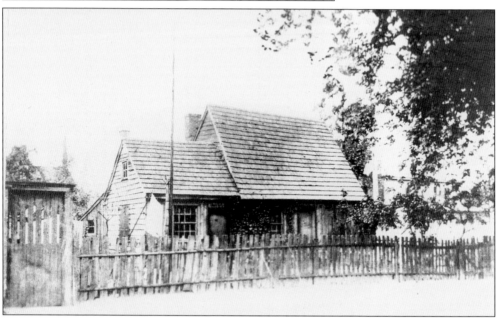

This 1.5-story house, known as the "Rain Splitter," was built in 1753. It is reputed that the pitch of the roof was so steep it would split rain drops that fell on it. The home was located at Fifth and Market Streets and stood for 150 years before the building was moved to make way for the expansion of the Gloucester Sanitary Milk Company. (Courtesy of the Gloucester County Historical Society.)

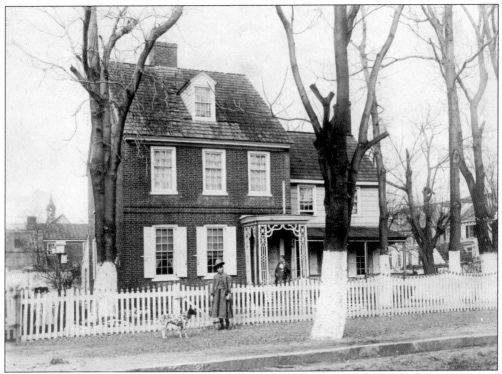

Here is the Arthur Powell house as it looked in 1890. The home was located on the corner of Sussex and Market Streets. The Powell residence was demolished in 1910 by the P.A. Stewart Company to make way for a row of homes. The house was originally built for James Bowman, a justice of the peace, who preformed Betsy Ross's marriage. Arthur Powell took ownership of the home in 1822. (Courtesy of Shad Agar.)

This is the Stephen Crocker house, located at the northeast corner of Monmouth Street and Broadway, in 1851. When the Presbyterian church's steeple collapsed in a cyclone, the wood was used to construct the large, fancy birdhouse seen in the right side of the yard. (Courtesy of the Harry Green collection.)

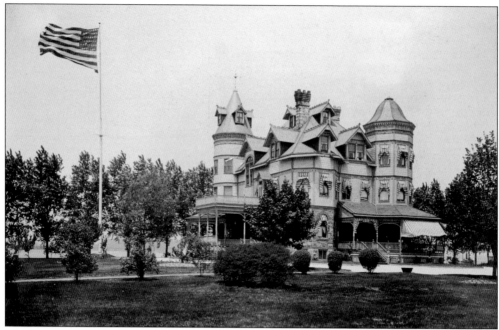

The home of William J. Thompson was located at the foot of Cumberland Street at the Delaware River. Thompson's mansion used 1 Delaware River as its address. The 22-room Victorian house was the work of Hazelhurst & Huckle Architects. When William Thompson filed bankruptcy, the federal government bought the property, and it was utilized as part of an immigration station. In the 1940s, when the US Coast Guard took control of the property, the home was demolished. (Above, courtesy of Bill and Dianne Fisher; below, courtesy of the Harry Demarest collection.)

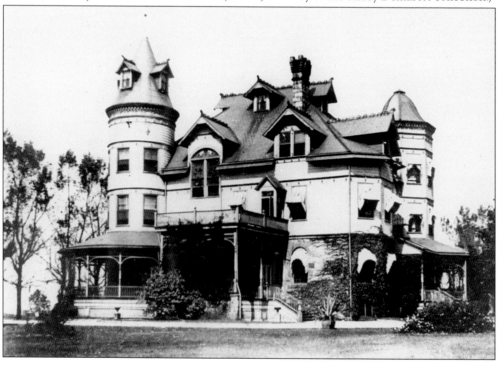

The Haley house is located at the corner of Brown and Monmouth Streets in the Monmouth Terrace section of town. The home was originally built as an office for Doctor Haley's medical practice. In 1937, Walter McCann relocated his funeral home from across the street at 842 Monmouth Street into the home. In the mid-1960s, Walter and John McCann passed away, and Gerald and Rosemary Healey purchased the business, now run by the fourth generation of Healey's as the McCann-Healey Funeral Home. (Courtesy of the Healey family.)

This photograph of 724 Hunter Street illustrates how larger homes were becoming popular at the end of the 19th century. These houses are great examples of Victorian architecture, some of which is based on plans by architect Stephen Decatur Button.

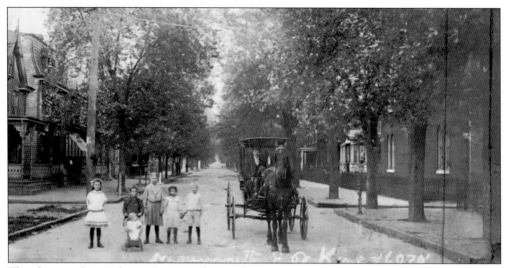

This photograph was taken on Monmouth Street looking east at Willow Street about 1907. The building to the right is the Methodist church. Today, the streetscape remains largely unchanged.

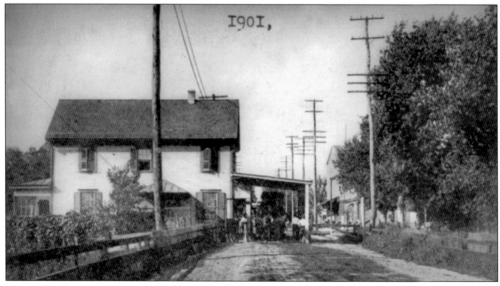

The old tollgate was located south of the intersection of Broadway below Jersey Avenue. The toll brought in revenue for the Camden and Woodbury Turnpike. This image was taken in 1901 and shows a rider has to stop his horse and wagon in order to pay a fee for using the roadway. (Courtesy of the Albert Corcoran collection.)

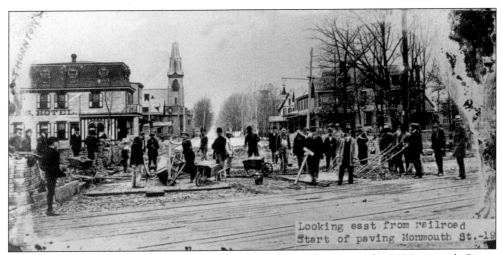

Looking east from railroad
Start of paving Monmouth St.-19

In the 1900s, a roadway paving project took a long time. This image shows Monmouth Street looking west from the railroad tracks toward Broadway. At that time, each brick was hand-laid with the craftsmanship of many local laborers. (Courtesy of the Louisa Llewellyn collection.)

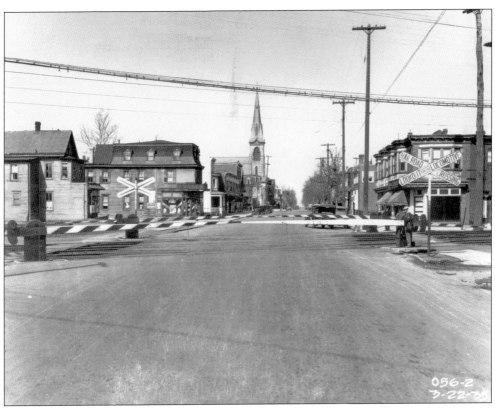

This is the same view of the streetscape only a few years later in 1935. The Monmouth Street roadway is now paved with asphalt, and the railroad track crossing has operating gates. The row of stores on the right is another product of local builder Patrick Stewart. (Courtesy of Ron Baile.)

Taken in 1880, this view is looking west on the 300 block of Monmouth Street. The first house visible on the left, which was constructed in 1868, is George W. Dickensheets's home. The next house, belonging to John C. Stinson, was built a few years later. The home on the corner, shown at the end of the row, belongs to Philip Foler, superintendent of the Gingham Mills. (Courtesy of Shad Agar.)

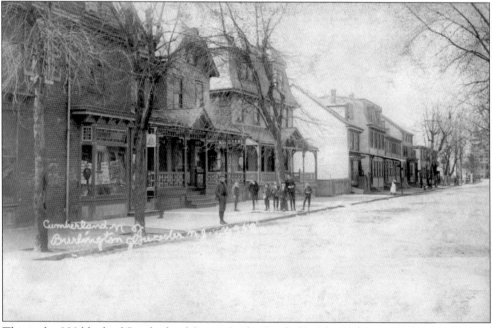

This is the 200 block of Cumberland Street. In the first half of the 20th century, businesses were mixed in with the residential homes, which gave each neighborhood character. These small local storefronts disappeared after the availability of automobiles. (Courtesy of VFW Museum Post 3620.)

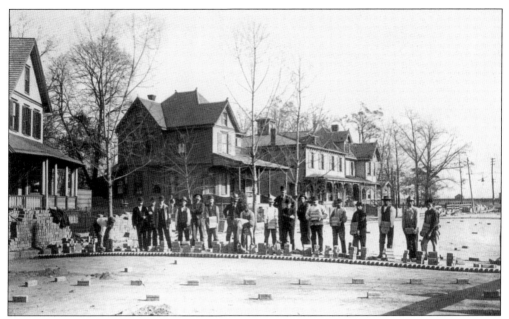

This photograph was taken in the early 1900s and shows the paving of Monmouth Street by laborers working in three-piece suits. Most of the city streets were paved with brick, river stone, or Belgium block. These materials were easily available due to Gloucester City being a shipping port. The heavy materials were used as ballast to weigh down the ships during sea voyages. (Courtesy of Shad Agar.)

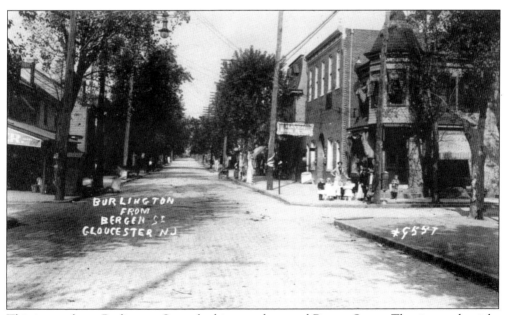

This image shows Burlington Street looking north toward Bergen Street. The sign to the right reads, "Hayes Motion Picture House." Mommy Hayes was one of the first to show motion pictures in Gloucester City. The theater later moved across the street to a larger building, now occupied by the VFW hall and museum. (Courtesy of VFW Museum Post 3620.)

This view shows Broadway at Monmouth Street looking north toward Camden. The photograph was taken at the turn of the century, when Broadway was a still residential neighborhood. Years later, the area would become the main artery in town, with many commercial businesses.

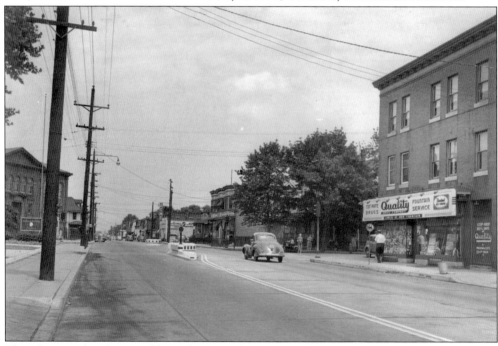

This photograph, taken roughly in the same place in the 1940s, shows dramatic differences. The roadway has been widened, and businesses line the street. The homes to the right in the above image have been replaced by strips of stores. Crossing barriers that were located in the middle of Broadway for pedestrians to use can be seen in this image. Patrick Stewart constructed the building on the right, housing Quality Drugs, as his office. (Courtesy of VFW Museum Post 3620.)

Five

SERVING THE COMMUNITY

Serving the public has been Gloucester City's job since it was first settled. The town became county seat for the boundaries of old Gloucester County from 1686 to 1786. The courts and the county government were set up in Gloucestertown. After the county seat moved to Woodbury, the town served the people in a new light. In the 1840s, it transformed from a village into an industrial city. This created a need for a police force and a fire department. The next large development occurred in 1868 when the town incorporated. Therefore, a city hall was built for all municipal business. The new city hall, pictured here, was to be the hub of this community's growing needs. (Courtesy of Ed Walens.)

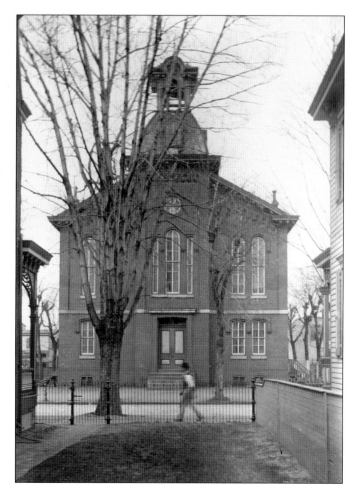

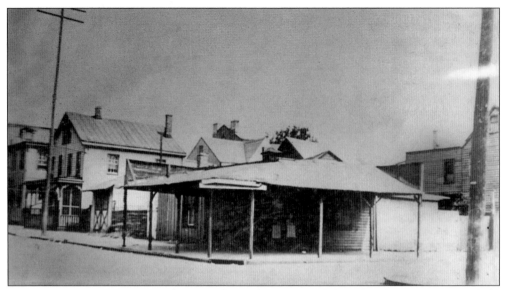

After the county seat was moved to Woodbury, the town needed a jail and a temporary city hall. This structure was located at the intersection of Burlington and Middlesex Streets. The building was a former butcher shop. Once the town was incorporated into a city in 1868, its first mayor, Samuel D. Mulford, was elected.

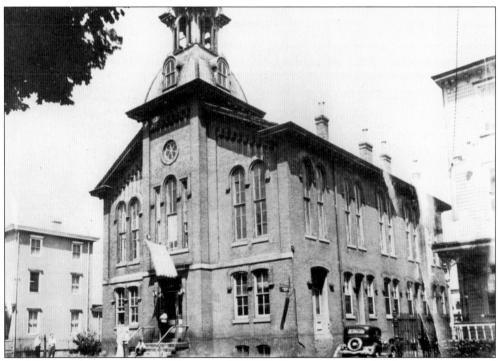

In 1869, city hall was constructed at a cost of $20,000. It was a two-story brick structure designed by Stephen Decatur Button. The first floor was home to municipal offices, and the second floor housed a large auditorium, which could provide hold up to 500 people. The building was demolished in 1939 in order to make room for a new city hall. (Courtesy of Louisa Llewellyn collection.)

The new city hall held offices and a courtroom, which was used by the police force for administrative issues. In addition, it had enough room for the fire station to store its apparatus. Today, the building still stands and operates as a courthouse and police station.

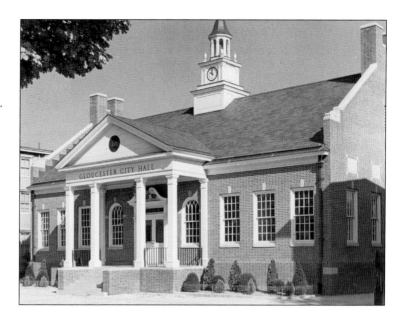

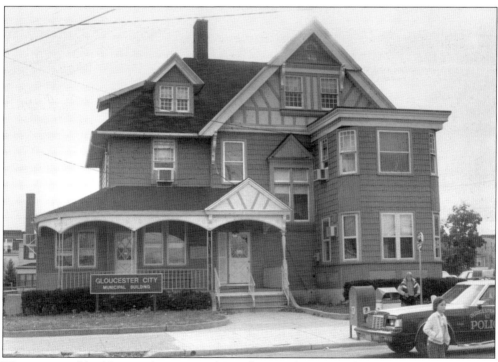

The municipal building at the corner of Broadway and Monmouth Street was originally the residence of Sheriff West. The structure was converted into a library and other city offices. Today, the city utilizes the building for administrative functions, such as offices for the city clerk, tax and finance officials, and the mayor. (Courtesy of the Louisa Llewellyn collection.)

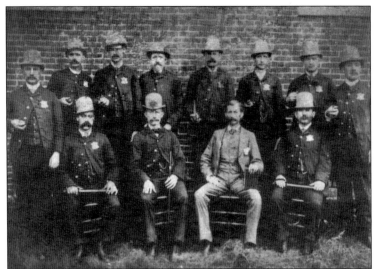

In this 1890s photograph of the Gloucester City Police Department are, from left to right, (standing) C. Charles White, Edward Cattell, James Aughenbaugh, Michael Bowe, Isaac Marple, William Stiles, Aden Owens, and Jack Flemming; (seated) William Keoun, unidentified, Mayor John R. Jackson, and Chief John H. Boylan.

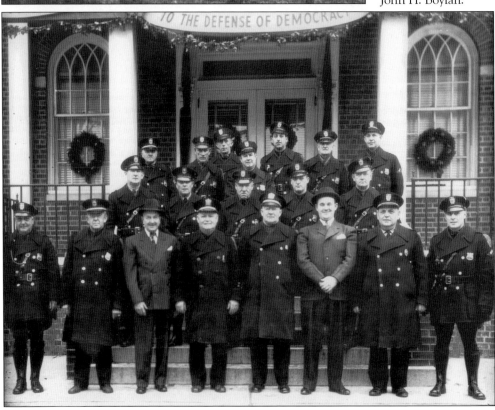

In 1942, members of the police force included, from left to right, (first row) George Smith, motorcycle driver; Sgt. Charles Brauning; Mayor A.D. Koenemann; Chief James W. Smith; Assistant Chief Thomas Moran; Michael Conroy, the director of police; Sgt. Archie Grey; and William Fowler, motorcycle driver; (second row) William Harkins, Walter Lane, Daniel Jennings, Edward Gallagher, and Thomas Bowe; (third row) Sgt. Albert Simpson, Frederick Blackburn, Leroy Jackson, Harry Lincoln, and Louis Bastien; (fourth row) Charles Reitz and Frank Keebler, motorcycle drivers.

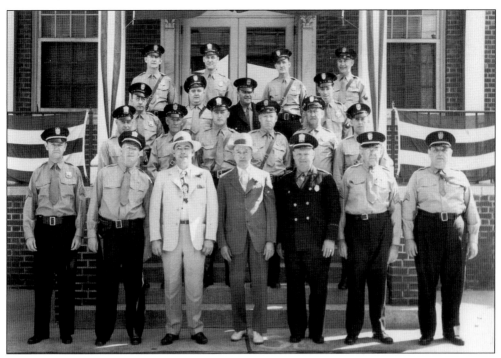

Members of the police force in May 1945 are, from left to right, (first row) Sgt. Thomas Bowe, acting night chief Thomas Moran, chairman of the police Matthew Reddy, Mayor A.D. Koenemann, Chief James W. Smith, Sgt. Charles Brauning, and Sgt. Archie Grey; (second row) motorcycle driver William Fowler, patrolmen Fredrick Blackburn, Edward Gallagher, Daniel Jennings, and Albert Gifford, and motorcycle driver Charles Reitz; (third row) Edward Francks, Louis Schili, Walter Lane, and patrolman Harry Smith; (fourth row) William Harkins, Edward Duffy, Edward Sweeney, and patrolman Louis Bastien. Not shown in the picture are officer Leroy Jackson and patrolman Frank Keebler. (Courtesy of VFW Museum Post 3620.)

Fire chief Patrick Mealey holds the reins of his horse at a stable on Jersey Avenue. Prior to 1875, the city did not have a fire department. If a fire occurred, the town relied on factories to provide their own fire departments and expected them to respond to fires within the city limits. (Courtesy of the Albert Corcoran collection.)

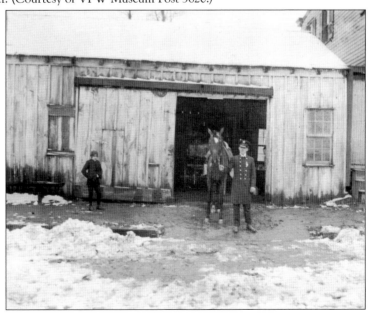

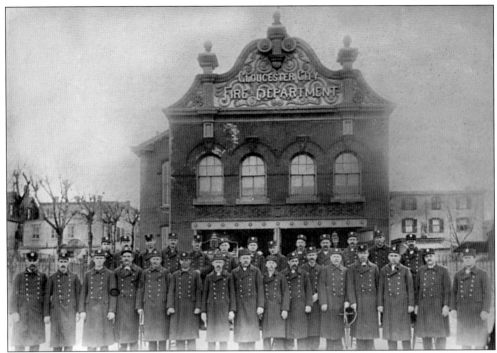

In March 1875, a fire broke out at Middlesex and Willow Streets in a shoe store owned by John Moffat, and, at the time, there was no city fire department. The quick reaction of the Washington and Ancona Mills Fire Departments extinguished the blaze. After this incident, a city fire department was organized. This photograph shows the fire department in 1889. (Courtesy of the Gloucester City Fire Department.)

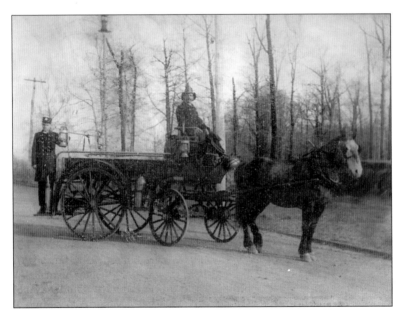

Before modern equipment was made available, volunteer firemen used a horse-drawn wagon to respond to a fire. Patrick Mealey was the first man to become fire chief in Gloucester City. (Courtesy of the Gloucester City Fire Department.)

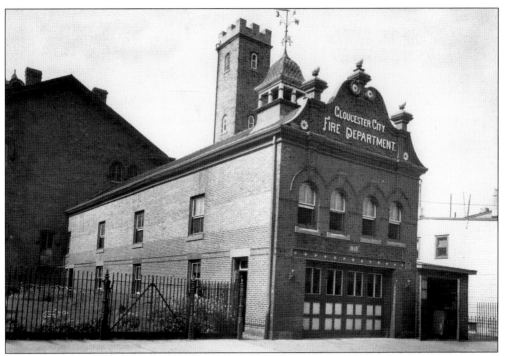

The first fire station was built in 1889 on Bergen Street. To the rear of the fire station is city hall. The fire station was operational until about 1939, when the structure was demolished in order to make room for the new city hall complex. The dated cornerstone can be viewed at the Gloucester City Historical Society. (Courtesy of the Gloucester City Fire Department.)

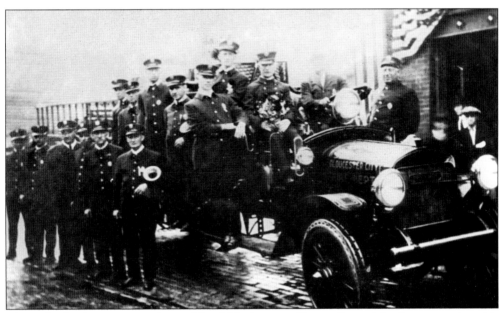

This is the fire department in front of the old firehouse on Bergen Street. Members are posing with new firefighting equipment. At that time, the department was made up of volunteers who would respond to fires at any hour of the day. (Courtesy of the Gloucester City Fire Department.)

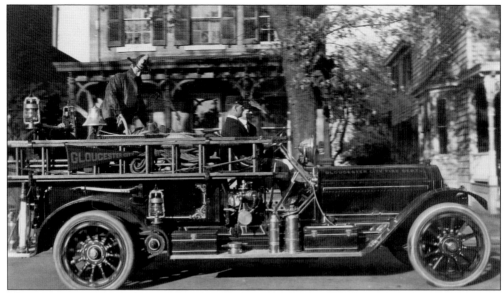

The city's first motorized water-pumper, which was chain driven, was purchased in 1914. This piece of equipment replaced the need for horse-drawn wagons. The two drivers are James Gilmore (left) and Thomas Gibson, and the man setting up the apparatus in the middle of the truck is unidentified. (Courtesy of Shad Agar.)

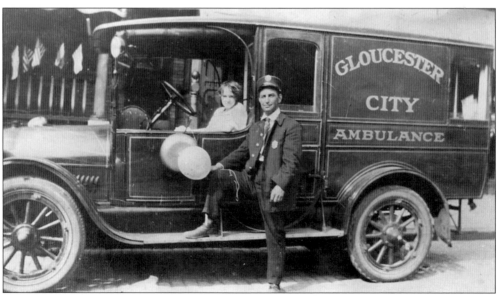

As the city fire department expanded, it needed more equipment. This is the city's first ambulance. Driver George Callahan stand at the running board, but the woman in the driver's seat is unidentified.

In 1940, a new fire station was constructed on Bergen Street. It is now a part of city hall. This picture was taken in the 1950s and shows Gloucester City Fire Engine Ladder No. 1, representing the best technology at that time. (Courtesy of VFW Museum Post 3620.)

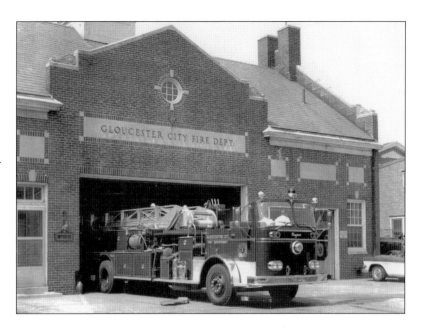

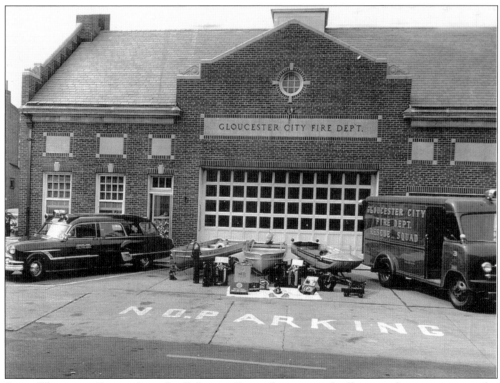

Since Gloucester City is along the Delaware River, the city needs all types of equipment in order to rescue people. Several boats were used as rescue equipment as was a special truck for towing and storing water rescue supplies.

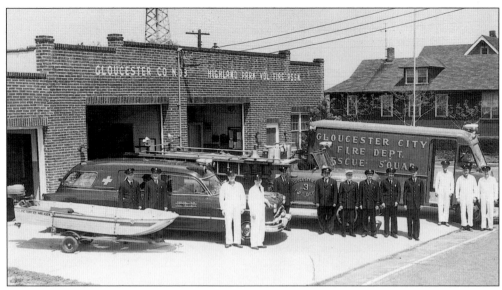

Since the fire department was organized in 1875, the city has relied on its volunteer firemen. Besides having a main headquarters located on Bergen Street, the city had three neighborhood stations. Gloucester Heights Fire Station, located on Nicholson Road, still operates as a station and community center today. Pine Grove Fire Station, located on Jersey Avenue, is active as a rental hall today but not as an operational fire station. Shown above is Highland Park Fire Station, located on Highland Boulevard. This station was founded in 1914 but closed in 1997 due to a lack of volunteers. The building is now used as a catering hall for local events. (Courtesy of Linda Locker.)

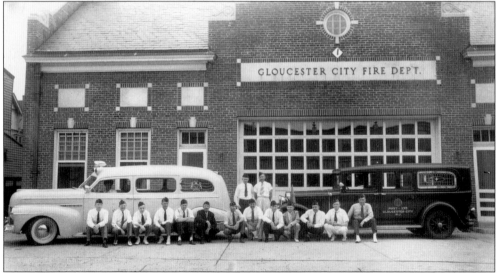

American Legion Post 135 members are posing with their new ambulance and the old ambulance that is being replaced. The legion members would volunteer their time for any resident who needed to be transported in the ambulance to the hospital at any hour of the day or night.

Air-raid wardens in 1942 are making use of a ward map. The wardens' training included special manuals that provided solutions to any type of advance made by a foreign attacker. The men in the picture are, from left to right, John Nash, Pete Kearney, Harry Demarest, and Mr. Crouthmahl. (Courtesy of the Harry Demarest collection.)

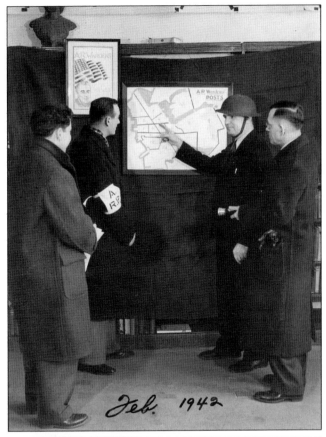

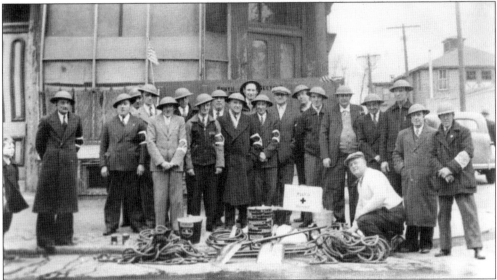

Here are John Gallagher and the air-raid wardens of the 1940s. These gentlemen volunteered to assist in any type of disaster. The men are displaying some of the equipment they would have to use if enemy bombers attacked Gloucester City from the air. (Courtesy of the Harry Demarest collection.)

Members of the Street Department of Gloucester City in 1944 are, from left to right, (standing) Pat McGlade, Joe Alexander, Tom Malone, Tom Kilcourse, Al Schules, Ray Weed, and Frank Venett; (sitting) Tom Callahan, supervisor of streets; Mayor Albanus Koenemann; Andy McHugh; Tom Crowder; Oscar Harris; and Ed McGuire.

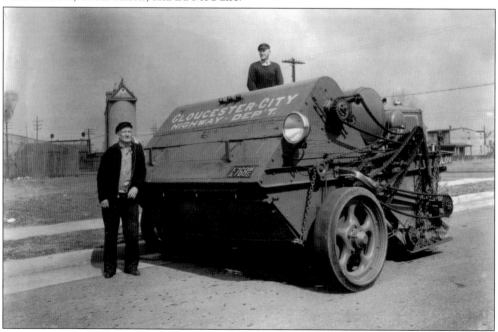

Street-sweeping equipment helped clean the roadways. This photograph was taken in the 1940s at the public works yard, which was located on Powell Street. (Courtesy of VFW Museum Post 3620.)

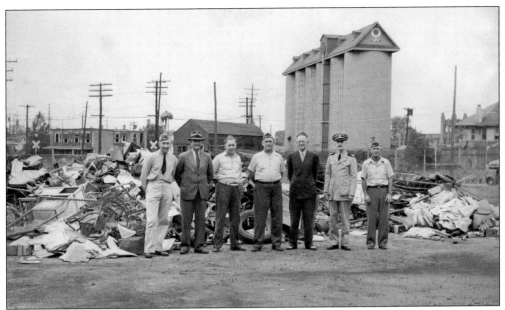

Judging by this photograph, taken in 1942, the World War II scrap drive was very successful and definitely benefited the war conservation effort. Those pictured are, from left to right, Robert Morris, Frank McQuaid, Albert Gifford, John F. Gorman, Mayor Koenemann, Lt. Henry I. Edwards, and Earl Kelly. In the background are the old coal silos of the Gallagher Brothers coal company. (Courtesy of R.S. Black.)

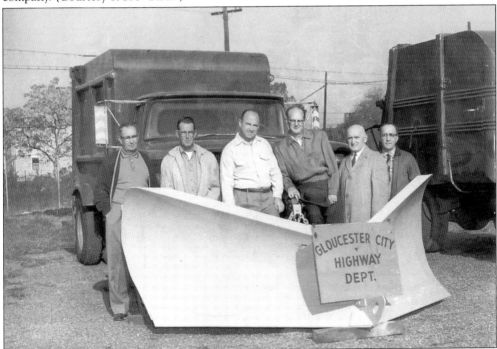

Members of the Gloucester City Highway Department show that they are ready for a snowstorm. The new plow ensures that the streets of Gloucester City will be cleared for automobile traffic, which was steadily increasing after World War II.

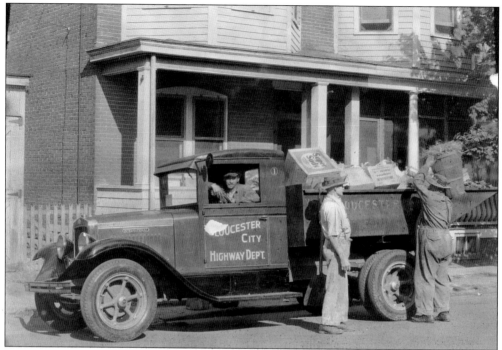

This is the first truck used by the highway department following the changeover from horse-drawn dump wagons of the 1930s. Loading the waste is Duck Ellenbark, driving the truck is John Rutter, and in the center is foreman John Davidson. (Courtesy of the Harry Green collection.)

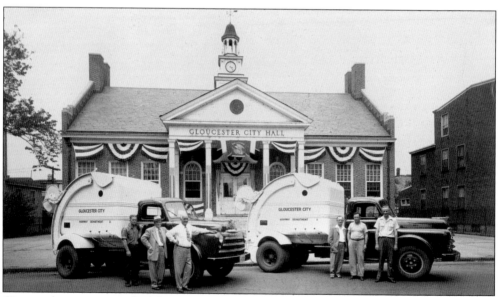

City employees are proud of their new sanitation equipment and are displaying it in front of city hall. The highway department's purpose has been to provide trash pickup for all of the city residents once they place their disposables at the curb. The department has provided several services, such as trash removal, street sweeping, leaf collection, and general maintenance of all city properties. (Courtesy of the E.K. Birch collection.)

At the same time the Gloucester City Water Plant was being built in 1883, so was the water tower on Paul Street. The tower has been operational ever since. Today, the structure provides water pressure for the residents of Monmouth Terrace and the Harrison-Brown tract. (Courtesy of the Martorano family.)

In 1880, the city fathers decided to build a water plant in order to provide water to all the residents of Gloucester City. The original building for the water plant was constructed in 1883. This is the only structure that the city owns that is in the National Register of Historic Places. (Courtesy of the Harry Demarest collection.)

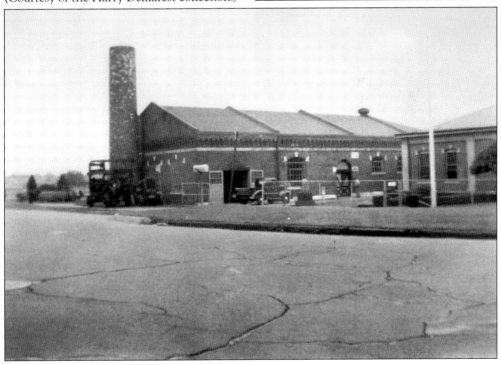

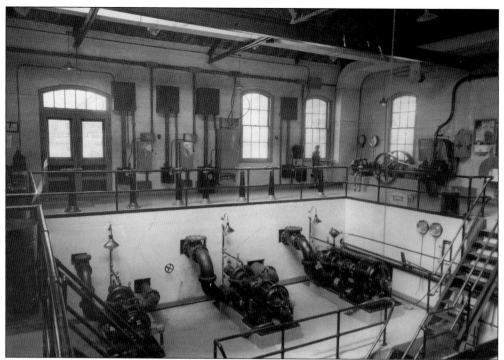

In 1922, a new water plant addition was constructed in order to provide better quality water throughout the city. This interior view of the building shows the well pumps that drew water from underground aquifers. The pumps that were installed when the building was constructed were still providing water at 100-percent capacity when a new automated electronic water plant was initialized in late 2010. These pumps were finally retired after 88 years of service. (Courtesy of the Gloucester City Utility Department.)

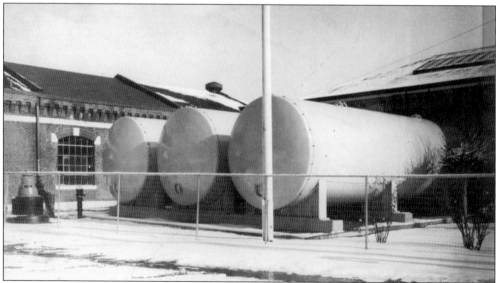

The filter tank system was installed at the waterworks in the late 1950s. These pieces of equipment were needed to improve the clarity and quality of water that the residents would receive from their home water taps. (Courtesy of the Gloucester City Utility Department.)

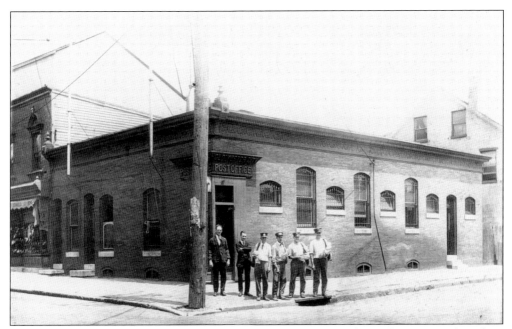

This is one of the early post office buildings in Gloucester City, located at King and Hudson Streets. The structure was very ornamental as opposed to most post offices today, which are usually basic in style and form. The postmaster and his postal workers are getting ready for their daily routes around the city. (Courtesy of VFW Museum Post 3620.)

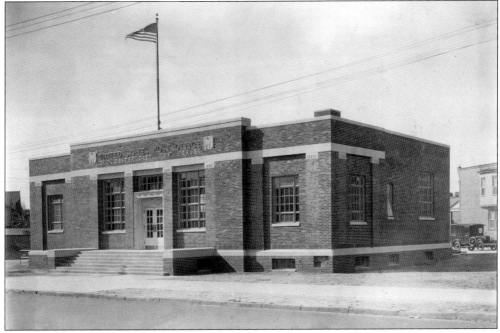

Gloucester City's post office has had several different locations. In 1935, the new postal service headquarters facility was constructed on the corner of Broadway and Ridgeway Street. The brick building is still being utilized today for postal sorting and delivery to Gloucester City residents. (Courtesy of the Louis C. Parker collection.)

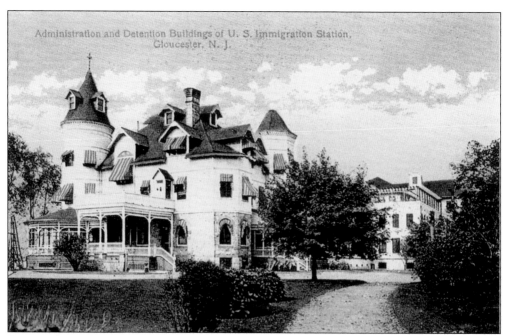

Administration and Detention Buildings of U. S. Immigration Station, Gloucester, N. J.

In 1911, the US government took ownership of the Thompson mansion. The structure was used for the superintendent of the immigration station. A new building, seen to the right, was used for processing immigrants until the 1940s. It was later a detainment center for undesirable aliens. (Courtesy of Frank Anello Jr.)

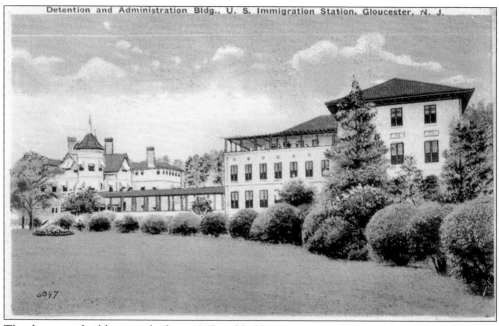

Detention and Administration Bldg., U. S. Immigration Station, Gloucester, N. J.

The detention building was built in 1915 and held many immigrants and illegal aliens thought to be a threat to the United States. This structure still stands and is today home to a global shipping company. The house was torn down in the 1940s when the US Coast Guard took over the property. (Courtesy of Frank Anello Jr.)

Six

TRANSPORTATION

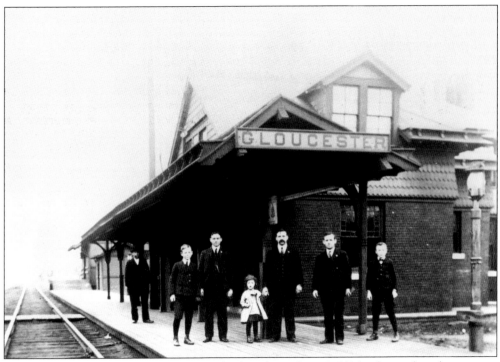

Transportation in Gloucester City dates back as far as June 1, 1696, when a ferry license was granted in order to go from New Jersey to Philadelphia. The first wherries were large sweep-ore-style boats, which could only accommodate a few people. Ferry operation continued for over 200 years until the ferry building was destroyed by fire in 1923. Within the town limits, horseback and stagecoach were the only means of transportation. In 1767, Arron Silver operated a stagecoach from Camden to Salem that made a stop at Hugg's Tavern. The first railroad came to town in 1838. A second railroad line was constructed in 1874, which became known as the "Peanut Line." Gloucester's first roadways dated back to the 1690s and, at the time, were just muddy, rutted pathways. Then in 1812, the county laid out a new road (Broadway) from Camden to Woodbury. The old tollgate at the south end of town operated until sometime in the early 20th century. This 1907 photograph is of the stationmaster and his family in front of the Monmouth Street train station. (Courtesy of the Parent family.)

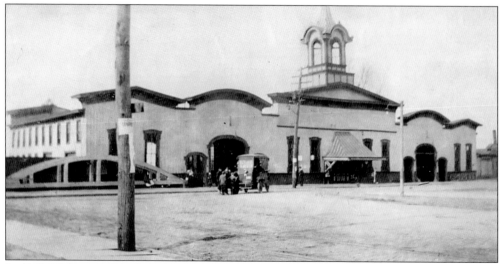

In 1865, William Farr and Archimedes Heckman took over as the main ferry operators, and in order to improve service, a new building was constructed about 1888. The introduction of two-decker ferries allowed twice the capacity to be transported in one crossing of the Delaware River. (Courtesy of the Louise Llewellyn collection.)

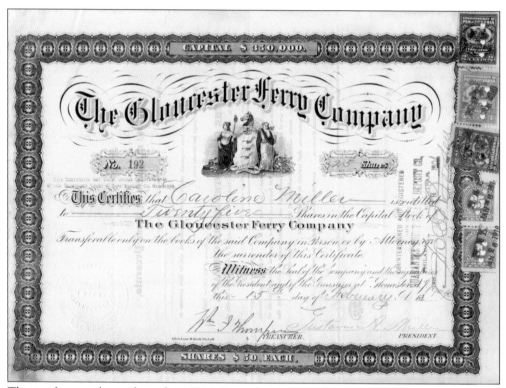

This is a ferry stock certificate from 1904. Since the business of ferry transportation seemed to be booming, several savvy investors took notice and purchased stock. All different types of locals and Philadelphians used the ferries for work and leisure when coming to Gloucester City. (Courtesy of the Funk family collection.)

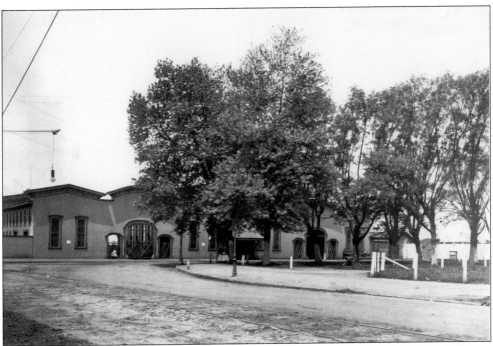

The ferry slip was at the foot of Jersey Avenue at the Delaware River, located adjacent to the Buena Vista Hotel. The boats would take droves of people from Gloucester Point to the Pennsylvania side and back. The ferry terminal is pictured in the late 1800s.

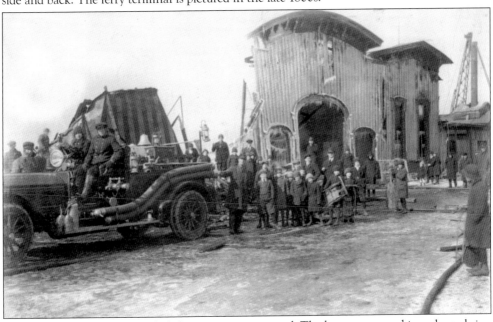

Even after the resort years ended, ferry service continued. The boats were used in order to bring people back and forth to work in the factories. Gloucester City still appealed to pleasure-seekers who came to the city from Philadelphia to enjoy alcoholic refreshments. In Gloucester City, drinking was permitted on Sundays—but not in Philadelphia. Sadly, the ferry terminal burned down in 1923 and was never replaced. (Courtesy of the Albert Corcoran collection.)

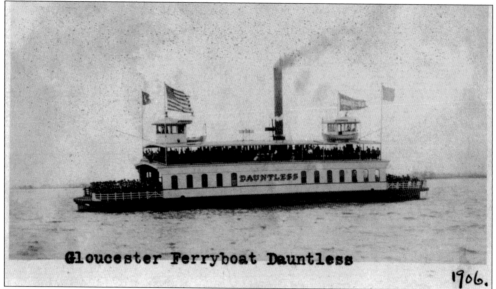

Gloucester Ferryboat Dauntless

1906.

In 1876, William M. Farr and Archimedes Heckman had the *Dauntless*, seen here in 1906, constructed. This boat, along with the *Peerless*, which was built four years earlier, would cross the river to South Street in Philadelphia. Years later, when William Thompson took over operations of the ferry, the *Fearless* was constructed. These three boats stayed in operation until ferry service stopped in the 1920s. (Courtesy of the Paul W. Schopp collection.)

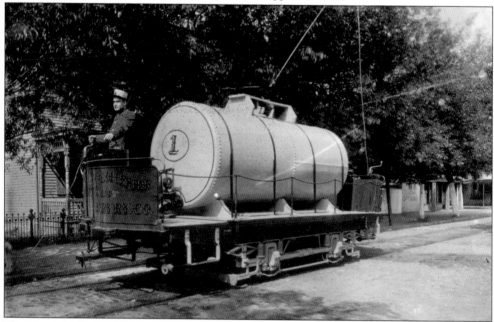

Thompson built a trolley line, the Camden, Gloucester & Woodbury Railway Company, which would carry people down to Washington Park. On the weekends, the trolleys would be filled to maximum capacity, so Thompson's venture was very profitable. During the summer months, the city requested a tank car to ride along the tracks and spray the street with water in order to cut down on dust. Here, the tank car is pulling out of the yard on the 200 block of Market Street. (Courtesy of Shad Agar.)

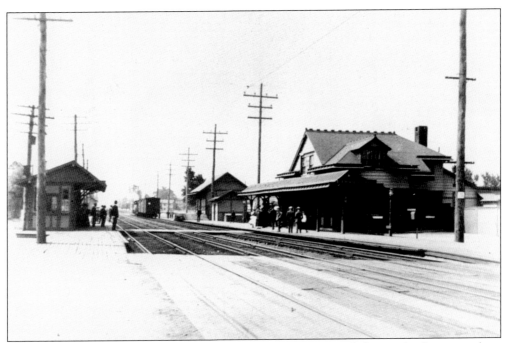

This is an image of the West Jersey Railroad station at Monmouth Street. At that time, there were three sets of tracks. An express track was provided to avoid slowing passenger service. The line used trolley or overhead wires through Gloucester City. (Courtesy of Ron Baile.)

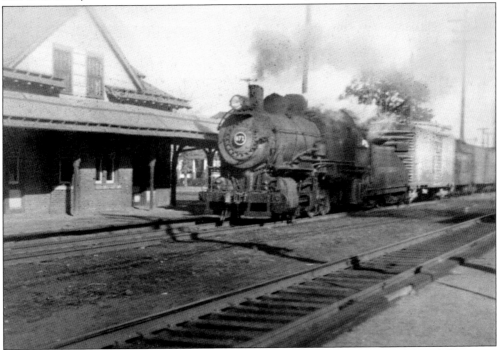

In this undated photograph, steam-powered switching engine No. 060 pulls in front of Gloucester Station. Although much of the traffic was from freight trains, there was still quite a large amount of commuter traffic on the train lines. (Courtesy of VFW Museum Post 3620.)

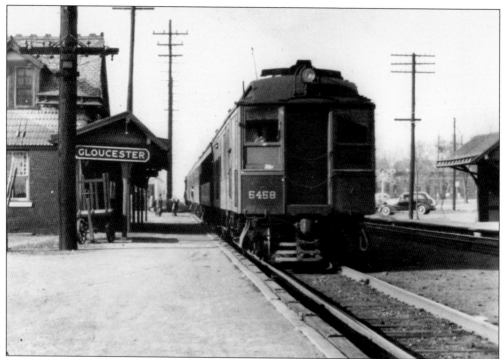

Multiple Unit Cars (MUs) were used to transport passengers on short runs. MUs were eventually discontinued because the railroad used them for long runs to the shore resorts, wearing them out. This type of system made train car separation very simple because it allowed each town to drop off or pick up the number of cars it needed to for its daily tasks. (Courtesy of Ron Baile.)

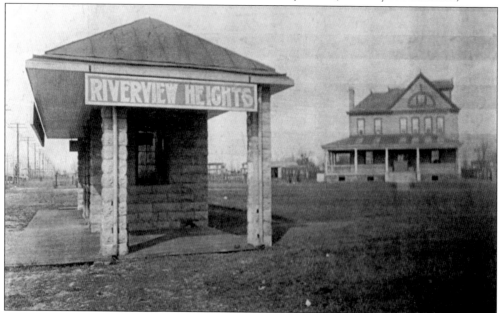

The old Riverview Heights Station was located at Kolher Street. This rail station was considered a flag stop, so there was no freight house at this location. Another local name for this stop was the South Gloucester Station. (Courtesy of VFW Museum Post 3620.)

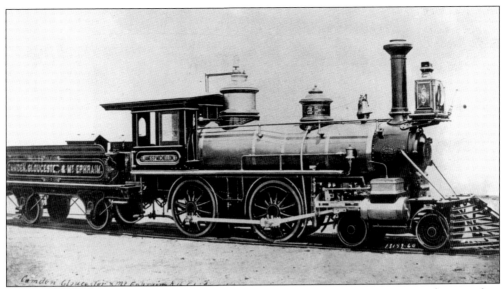

In 1865, David S. Brown organized the Camden, Gloucester & Mount Ephraim Railway to assist industries growing in Gloucester. In 1876, the railroad ran from Camden and followed a path along Newton Creek to Mount Ephraim. The rails later extended down south to Grenloch. This is one of two early steam-powered locomotives that traveled back and forth along this line. (Courtesy of the Louisa Llewellyn collection.)

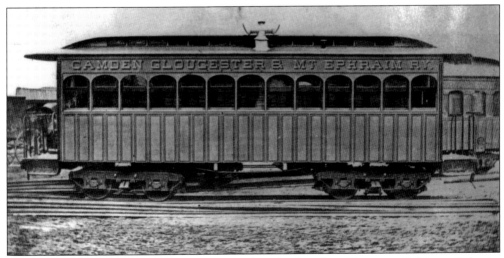

When the train line was originally constructed as the Camden, Gloucester & Mount Ephraim Railway, it was a narrow-gauge railroad, giving it the nickname the Peanut Line. The line served various types of freight as well as providing passenger travel. Pictured here is one of the closed (wintertime) passenger cars. (Courtesy of VFW Museum Post 3620.)

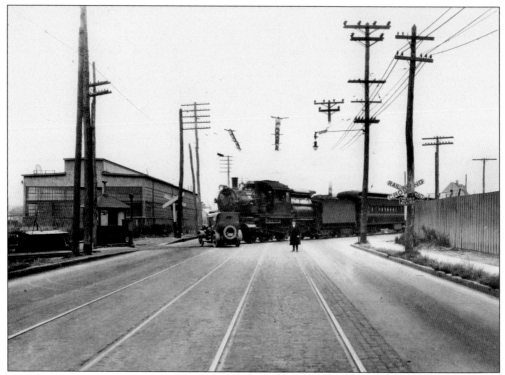

In 1929, this is how the intersection of Broadway and King Street looked at the grade crossing. The locomotive is southbound on the Grenloch Branch. This photograph was probably staged by the railroad to prove the lack of visibility due to the high fence to the right. (Courtesy of Ron Baile.)

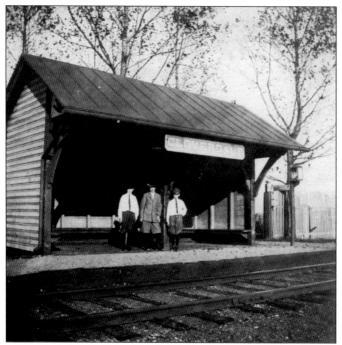

The Peanut Line had four stations located in Gloucester City. The North Gloucester Station, which also housed a freight house, was located at Salem Street between Burlington and King Streets. The other three stops were passenger stations. They were located at Johnson and Hudson Streets, Roseland and Klemm Avenues, and Cloverdale (pictured), which was located at the end of Park Avenue. (Courtesy of the Albert Corcoran collection.)

Beginning in the 1940s, talk of a second bridge crossing the Delaware River was tossed around. Construction started in August 1953 on the Walt Whitman Bridge. In this photograph, construction of the Gloucester City anchorage is nearing completion. The structure is used to resist the pull of the bridge's main cables. The schedule to complete the bridge was just four years. (Courtesy of the Delaware River Port Authority.)

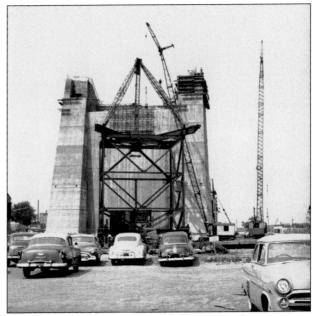

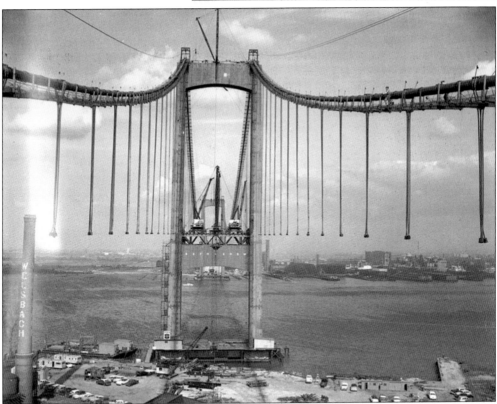

In preparation for installing the roadway deck, workers have installed ropes from the two main cables. The roadway was lifted from the ground by the cranes seen on the Gloucester-side tower. The bridge would be wide enough to accommodate seven lanes of traffic. The Welsbach smokestack can be seen in the bottom left-hand corner. (Courtesy of the Delaware River Port Authority.)

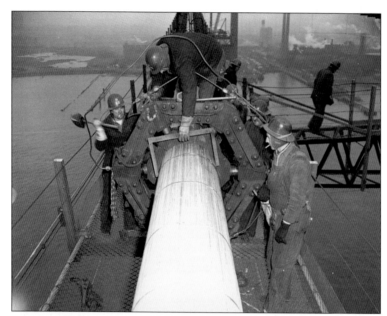

Workers are measuring the main cable to ensure that it meets the proper diameter. In order to reach the correct diameter, the hexagonal hydraulic jack is used to squeeze the cable into the proper size and shape. The bridge support cables on each side of the bridge are made up of 60,000 miles of steel wire. (Courtesy of the Delaware River Port Authority.)

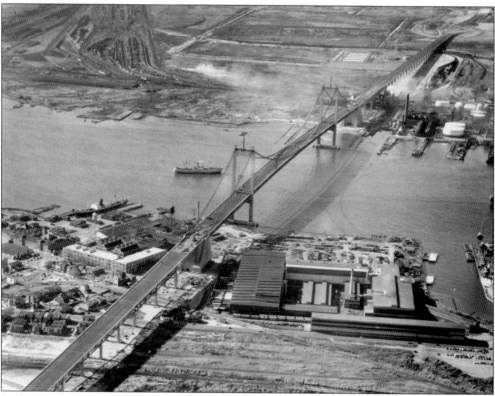

In this aerial photograph, work on the span is nearing completion. In addition to the bridge, the roadways in southern New Jersey had to be upgraded, which prompted many people to flock to the suburbs. On May 15, 1957, the Walt Whitman Bridge linking Philadelphia with Gloucester City was opened with a large ceremony, and the first vehicle crossed at midnight. (Courtesy of the Delaware River Port Authority.)

Seven

BUSINESS AND INDUSTRY

Since Gloucester City's early settlement, there has always been some sort of business in town, whether it was bartering or trading for services or food. David S. Brown was the developer who turned a deserted little village into a booming industrial, modern city. In 1844, Brown began with the Gloucester Manufacturing Company, which was followed by many other factories along the Delaware River waterfront. Brown had a vision to create industry along the river. The building above was one of the town's most recognizable structures, which was located at the corner of Monmouth and King Streets. In 1885, this was Wamsely's Drugstore. Those pictured are, from left to right, police chief Ike Marple, William J. Healey, Jim Leny (leaning on a tree), and Dr. and Mrs. Wamsley and their children Clare and William. Unfortunately, the building met its demise by fire in the late 1980s. (Courtesy of Frank Anello Jr.)

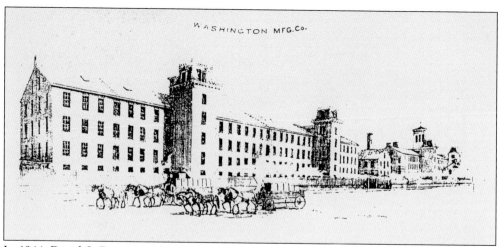

In 1844, David S. Brown purchased a plot of land on which to build his new mill. He figured it was more cost-effective to build a mill instead of continuing to import dry goods from New England. Brown began to produce his own products here in Gloucester City. His first investment was the construction of Washington Mills and Gloucester Manufacturing Company, which was located between Mercer and Monmouth Streets on the riverfront. The mill brought about the rise of modern Gloucester City. (Courtesy of Patricia Robertson.)

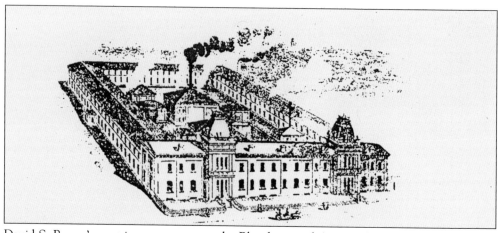

David S. Brown's next investments were the Bleachery and Ancona Printing Company. Built side by side, both factories stood just north of the Washington Mills property. Brown thought it was easier to produce and process the dry goods in his own factories, which employed hundreds of people who lived in Gloucester City. Working long hours for small amounts of wages, the employees included men, women, and children. (Courtesy of Patricia Robertson.)

Another works of Davis S. Brown was the Gloucester Ironworks, which opened in 1871. The works was located on the north end of the town, where the present-day Walt Whitman Bridge sits. The company produced a wide variety of cast iron pipes, fire hydrants, and steam and gas fittings and valves. The ironworks closed in 1891 and eventually became part of New York Shipbuilding's south yard. (Courtesy of the Paul W. Schopp collection.)

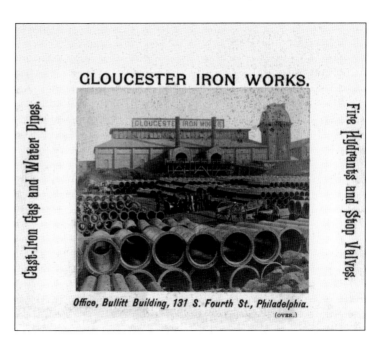

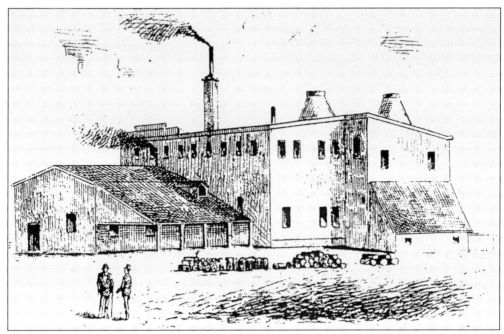

Located along Water Street, the Terra-Cotta Works produced clay products. The factory location was perfect since the Delaware River provided a nearly limitless amount of raw clay material. The company's main product was clay piping, which was utilized to develop all of the city's new underground sewer lines. However, the process of removing the clay destroyed the shad fishing operations that had made Gloucester City famous. (Courtesy of Patricia Robertson.)

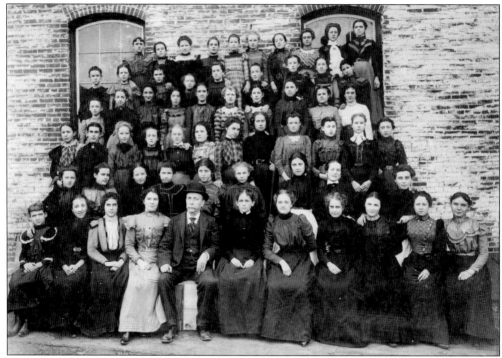

Bleachery workers in this 1892 photograph include (first row) Mamic McAlier, A.M. Ritchie, M. Patton, Bertha Krowpan, and Claire Larclier; (second row) Maud Mailley, Mrs. Tallock, Jessie Lipestt, Olive Ducey, Mattie Work, Hope Brick, and Anna Fitzgerald; (third row) Miss Sandy, Olive Mailley, Mrs. Mckenna, Mariah Heritage, and Lilly McElhone; (fourth row) Marge Pursglove, Miss Lyons, Mrs. Anderson, Anna Coyle, and Nellie Porch; (fifth row) Barbara Vickers, Lizzy Murphy, Jessie Brandt, and Ms. Fair; (sixth row) Edward Traux, Bessie McAlier, Emma Hemeral, Helen Lyons, Lizzie Cattell, Mazzie Neiman, Jessie Starr, and A. Hill. (Courtesy of Gloucester County Historical Society.)

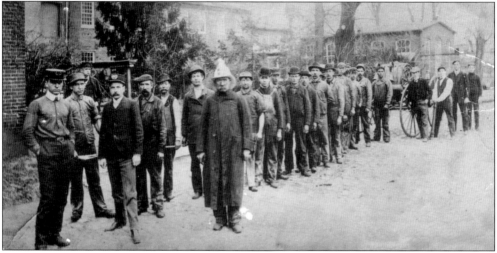

The Bleachery Fire Department in 1890 includes, from left to right in the foreground, Stanley Rodgers, Jim Stewart, Carlos Allen, unidentified, Ike Peppitt Sr., Ike Peppitt Jr., and Chief Ashley Leeds. (Courtesy of Shad Agar.)

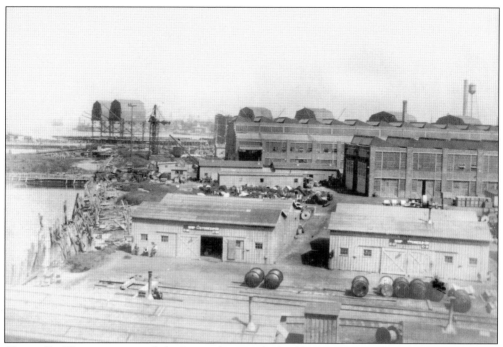

Christoffer Hannevig created the Pennsylvania Shipbuilding Company during World War I. A shortage of Allied shipping created a shipbuilding boom. Later known as the Pusey and Jones Shipyard, it was located at the foot of Charles Street. (Courtesy of VFW Museum Post 3620.)

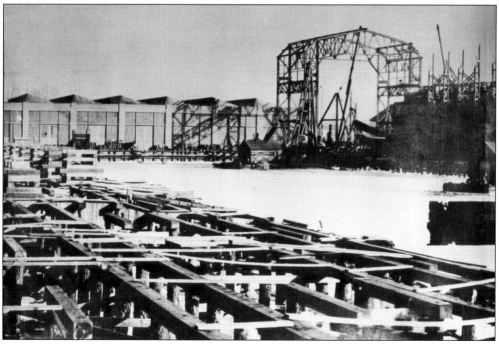

The Pusey and Jones Shipyard had a different approach to launching a ship than most other shipyards at that time. The ship hulls were built on level ground and then launched sideways into the Delaware River. It was the only shipyard on the Delaware River to do this.

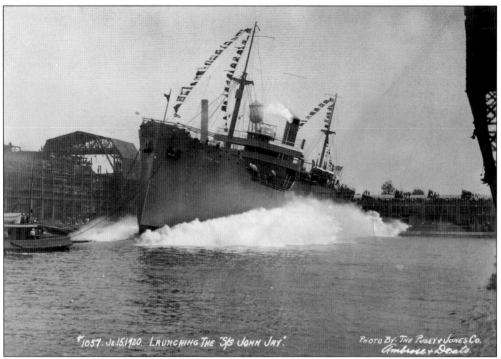

On June 15, 1920, the SS *John Jay* was launched sideways into the Delaware River. The Pusey and Jones Shipyard survived into the early 1920s. (Courtesy of the Verna Cubbler collection.)

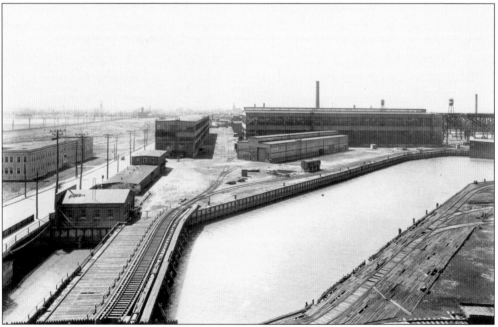

Although its street address was in Camden, New York Ship's south yard was actually located in both Camden and Gloucester City—on the border between the two municipalities. This view is looking north along Broadway toward the present-day location of the Walt Whitman Bridge. (Courtesy of Funk family collection.)

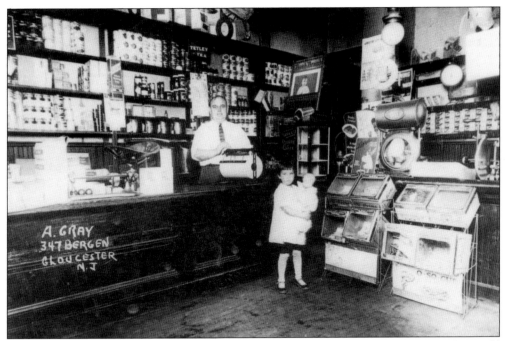

Archie Gray had a grocery store at the corner of Bergen and Sussex Streets. In 1921, Gray sold products such as Tetley tea, Bond bread, and other products, some of them still being produced today. Before large grocery chains existed, every corner in town had a local store, like this, which provided products for purchase close to home. (Courtesy of Shad Agar.)

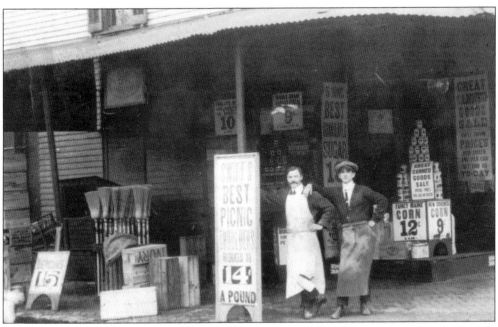

This is Dunlap's Market, and standing out front are an unidentified man and Joseph N. Kain (right). Take notice of the great canned goods sale at the store. At that time, corn was only 12¢ a can, and a shoulder of pork was only 14¢ a pound. (Courtesy of Frank Anello Jr.)

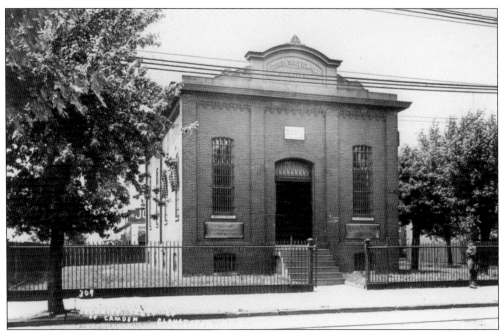

The Gloucester City Savings Institution was founded in the 1870s by local merchants and citizens. The bank was housed in the Wamsley Building until this secure structure was built in 1883. The bank merged with the Gloucester City Trust Company and relocated to a building on Monmouth Street. The former bank building was purchased by Charlie Goodmen in 1939 and converted into Beth El Synagogue. Designed by Stephen Decatur Button, the structure still sits at the corner of King and Monmouth Streets. (Courtesy of Ed Walens.)

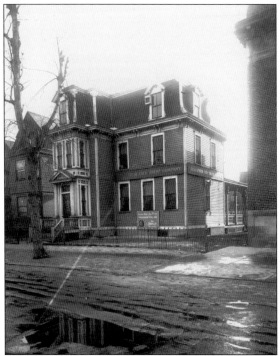

The Gloucester City Trust Company was located on Monmouth Street, between Atlantic Street and Broadway. When the bank merged with Gloucester City Savings Bank, a new brick building was constructed. To the right of the photograph is the corner of the new brick structure, which still houses a bank on the 500 block of Monmouth Street. The Trust Company Building was torn down to make way for a parking lot. (Courtesy of VFW Museum Post 3620.)

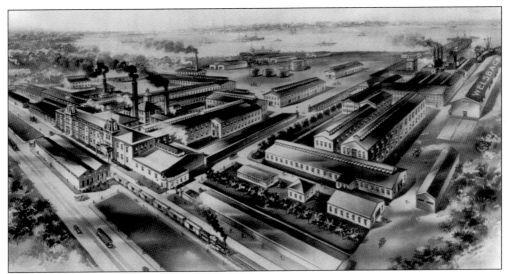

The Welsbach Lighting Company operated in Gloucester City from 1888 to 1940 along the Delaware Waterfront. The company started out as a small business using the old Ancona Print Works Buildings. Welsbach produced mantles for gas-lighting elements and gas-powered appliances. The business employed hundreds of city residents. Madame Curie came to visit Gloucester City when she visited the United States and toured the facility. After the development of the tungsten filament lamp, the gas-lighting mantles began to fall out of vogue, and production was no longer in demand. (Courtesy of VFW Museum Post 3620.)

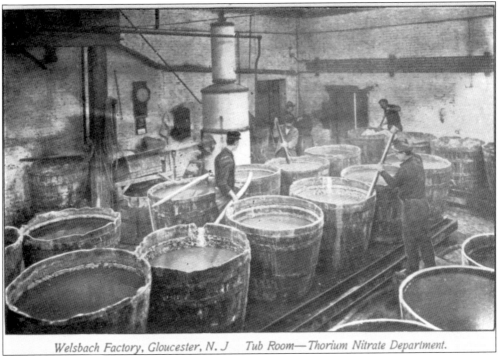

Welsbach Factory, Gloucester, N. J Tub Room—Thorium Nitrate Department.

Without any protective personal gear, these workmen in the "Tub Room—Thorium Nitrate Department" at the Welsbach factory are mixing a colloidal solution containing thorium nitrate, a radioactive compound, in wooden tubs. (Courtesy of the Parent family.)

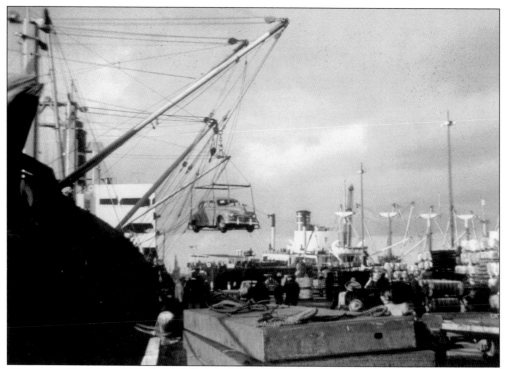

Gloucester City's location along the Delaware River made it a great location for importing and exporting all sorts of goods. Today, the city still has an active port, which receives imported produce from South America. In this photograph, an automobile is being lifted into a freight boat. (Courtesy of VFW Museum Post 3620.)

After the Welsbach Factory closed down in the 1940s, the Armstrong Cork Company purchased the property. This business imported raw cork from Spain and Portugal and then converted the raw materials into household products. This was the yard where unloaded cork was stacked and sorted before it was taken into the factory to be processed.

There were many coal dealers throughout the city who used horse-drawn wagons to make deliveries to local residents. During warmer seasons, many coal dealers would diversify and sell other products, such as ice, building materials, and hardware, in order to make revenue. (Courtesy of the Harry Demarest collection.)

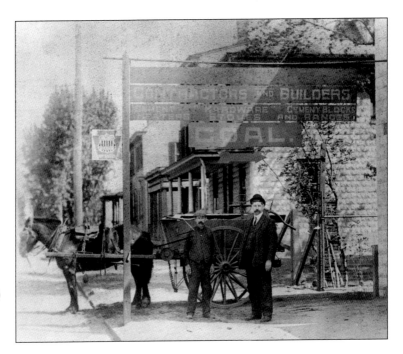

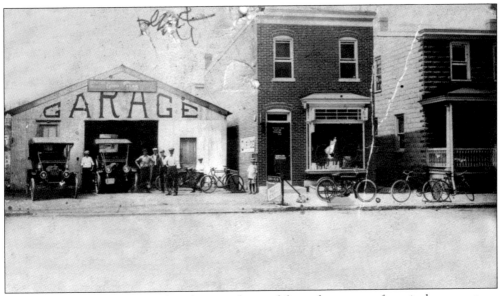

As automobile traffic increased in the city, the need for and presence of repair shops went up. This automobile garage was located at Market Street and Broadway and had been converted from a stable. Since automobiles were becoming an item that many households needed, it seemed that service stations, which provided gas and repairs, were popping up everywhere around town. The building to the right of the garage was the location of Kings Pharmacy for years. (Courtesy of the Harry Demarest collection.)

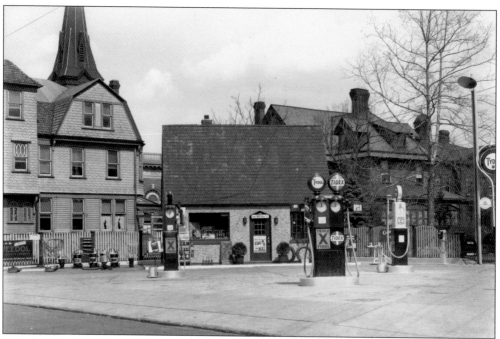

A Tydol gas station was located at the northwest corner of Broadway and Somerset Street. In the background are some landmarks, including St. Mary's steeple, the Sheriff West home, and the Monmouth Street School. Today, this site is home to a Chinese restaurant. (Courtesy of Ed Walens.)

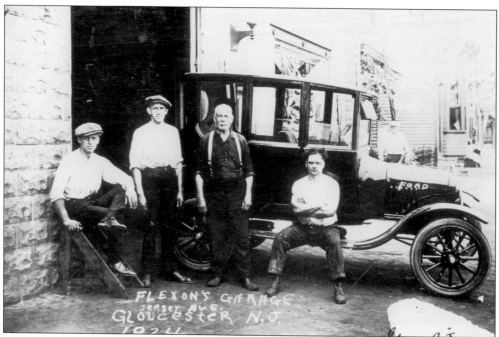

This photograph, taken in 1924, shows the workers at Flexon's Garage, which was located on Jersey Avenue. Walter Flexon sold Ford automobiles from this shop. On the second floor of the building was radio station WRAX. (Courtesy of VFW Museum Post 3620.)

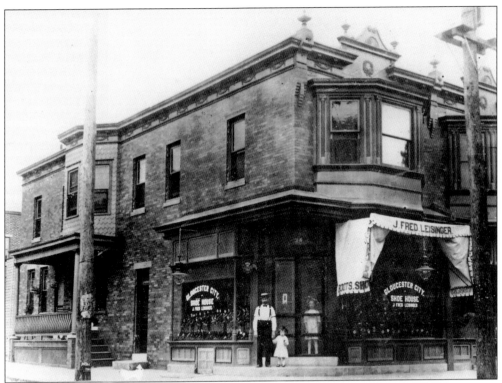

Fred Leisinger was a German immigrant who opened a shoe store in 1890. While on a trip to Germany in 1911, Leisinger fell in love with a hand-carved bar. He had the ornate piece of furniture shipped to his shoe store in Gloucester City. On June 1, 1912, the entrepreneur reopened his establishment as Leisinger's Saloon. On the corner of Hudson and Burlington Streets, a bar business still operates at the location under the name Max's Café. (Courtesy of VFW Museum Post 3620.)

As businesses expanded along Broadway, many residences were converted into stores. This house replaced the Crocker Cottage. The photograph taken in the 1950s shows the attached flower shop. The structure is still both a flower shop and a home today. The business is now called Sunshine Flowers and Gifts. (Courtesy of Gloucester City.)

REMODELING

Big or Little
Large or Small

We Can Supply
Your Needs.

STINSON & DICKENSHEETS, Inc.

Lumber — Millwork — Hardware — Building Materials

King & Market Sts., Gloucester City, N. J.

Phone Glo. 6-0308 & 6-0309

Shortly after David Brown brought industry into town, many new businesses serving the community sprang up all over the city. The lumberyard that would become Stinson & Dickensheets Lumber Company opened in 1849 in order to support the construction of the various new homes being built all over the area. This is an advertisement that ran in the *Gloucester City News* in the 1950s. The lumber business survived for over 130 years in the city until it closed in the 1970s. (Courtesy of the Parent family.)

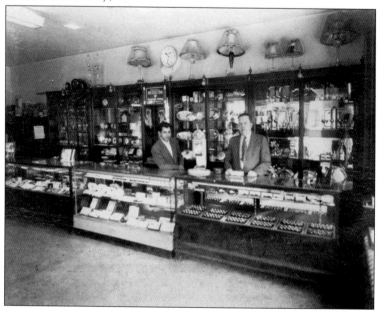

Dr. William J. Gannon began an optometric practice in the early 1920s at the corner of Fourth and Market Streets. His sons William Jr. and John "Jack" later joined the business and enlarged the store to provide jewelry and, later, electronics. Behind the counter are Dr. William Gannon (right) and an unidentified man. (Courtesy of the Gannon family.)

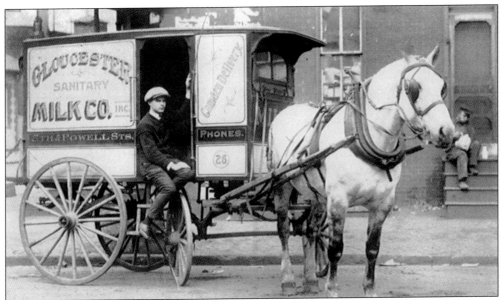

Edmund Cann and his trusty horse Bessie hauled gallons of milk to local residents. The Gloucester Sanitary Milk Company was located at Fifth Street, between Market and Powell Streets. The Rain Splitter house was moved in 1903 to expand the dairy. (Courtesy of Ed Walens.)

Archie's Tavern was first located on the northeast corner of Broadway and Essex Street. This tavern, like many restaurants in the mid-1900s, served famous deviled seafood platters, a popular Depression-era food. After the restaurant moved to Passaic Street, the name of the business here changed to Emilio's, then Ferry's, and finally the Pirates Den. (Courtesy of the Oekrud collection.)

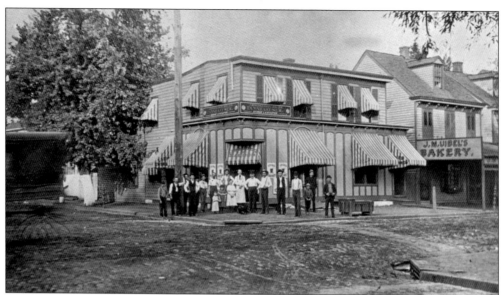

Lancaster's Saloon and Uibel's Bakery were located at Third Street and Jersey Avenue. This photograph was taken in 1895. Not including the three young girls in front—Phoebe Lancaster (left), Mary Cramer (center), and Kate Lancaster—those shown are, from left to right, Whitney Marshall, Jack Dobson, Cal Dobson, Ed Thornton, Aurrie Dobson, Joe Durding, Bill Hagen, ? Keany, George Lancaster, Wilpely Mayberry, Gill Sullivan, Al Marshall, Jack Keenan, unidentified, and George Parvin. The building was demolished in 1932 in order to build a service station.

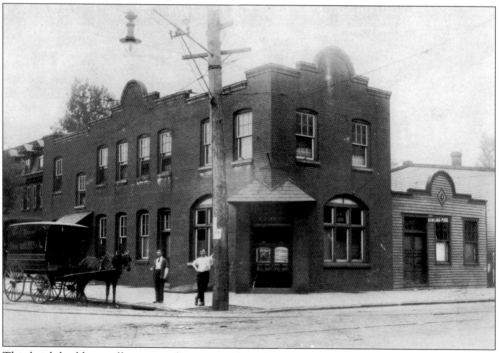

This brick building still exists at the corner of Market and King Streets. It was constructed as a factory to produce windows and doors. During the racetrack era, it served as a tavern. For years, PAP wholesale general store occupied the structure. (Courtesy of Frank Anello Jr.)

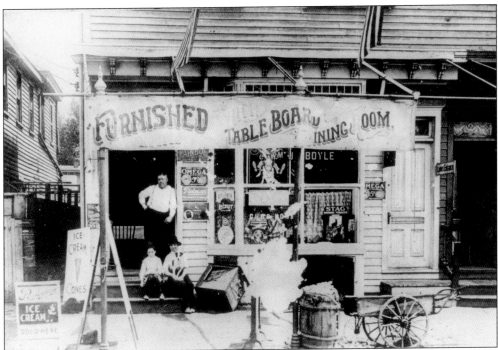

William J. Boyle owned and operated this "Furnished with Table Board Dining Room." Standing in the doorway is William Boyle, and seated are his daughters Cassie Boyle (Birney) Ashton and Mame Boyle Robinson. Notice the ladies' entrance sign on the door; their door was located on the right side of the building. (Courtesy of VFW Museum Post 3620.)

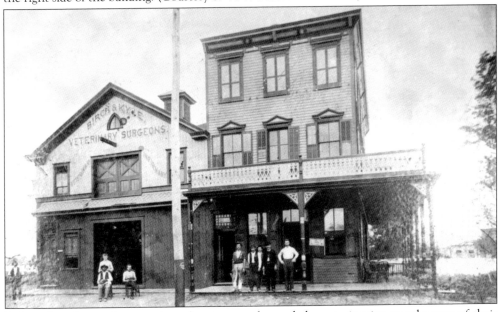

Before the advent of cars and mechanics, people needed a veterinarian to take care of their horses. Birch & Kyle Veterinary Surgeons was located at Sixth Street and Jersey Avenue. The building to the right operated in 1903 as the Willow Grove Hotel. (Courtesy of the Harry Demarest collection.)

The John Key's and Seitz's businesses at 309 and 311 Jersey Avenue were also places where people could stop off to get a libation. Seitz's has saloon doors, and Key's Saloon also has a side entrance for women, which was in between the two establishments. (Courtesy of Shad Agar.)

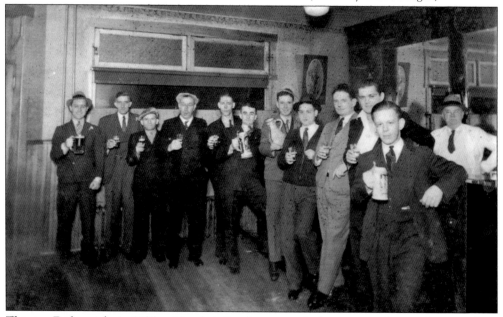

This is a Friday night in 1937 at Murphy's Bar, known as the happening place to frequent then. It was located at Burlington and Somerset Streets. Those pictured are identified as, from left to right, Ed Pack, Lew. Fulbrick, F. McGuckin, H. McGabe, Bill Oxley, Hank Lyons, Jack Nash, Jim McIntyre, Tom Curran, Ralph Handcock, Court Bevan, and John Murphy (behind bar).

The Dixie Hotel and Tavern was located at the corner of Burlington and Ridgeway Streets. The Odd Fellows Lodge No. 37 held its meetings on the third floor of this business. Despite the changing names and owners throughout the years, the building was recently renovated and operates as pub and grill. (Courtesy of the Louisa Llewellyn collection.)

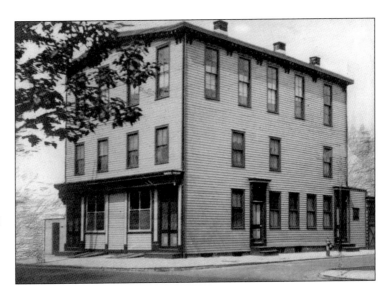

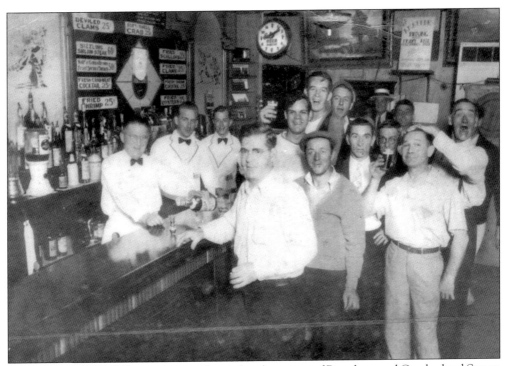

Pohle's Bar and Family Restaurant was located at the corner of Broadway and Cumberland Street. In this 1935 photograph, the bartenders are, from left to right, Pat Clark, unidentified, and Leo Burrie. The building survived several years as a bar before being torn down. Today, the property is home to a bank, located next to the post office. (Courtesy of the Harry Lyon collection.)

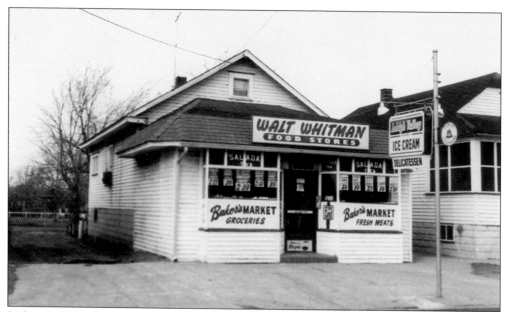

Before the availability of a supermarket, there were local corner stores, like this one. These corner stores were a common sight in the city. Baker's Market, also known as Humpey's, was located along Nicholson Road in the Gloucester Heights section of the town. (Courtesy of Gloucester City.)

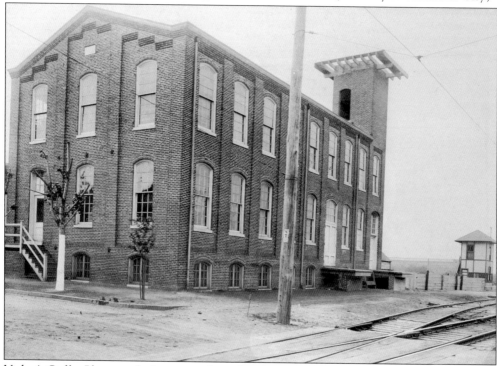

Vicker's Coffee Plant was built next to the railroad on Essex Street in 1903. Through the years, additions have been made to the structure. In 1959, Fred Binter purchased the old building and converted it into a soap-processing factory. The Binter family continues to operate the business today. (Courtesy of the Albert Corcoran collection.)

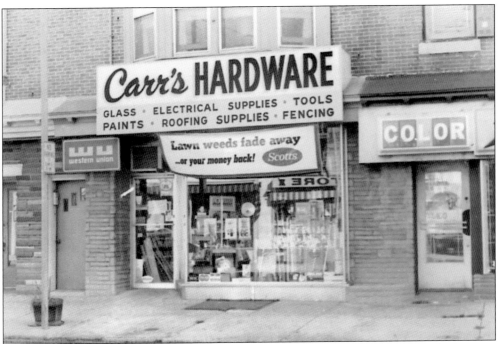

In 1968, Franklin Carr Sr. opened a hardware store at 520 Monmouth Street. As the business expanded, the family relocated to the old Acme Building at 22 North Broadway. The Carr family still owns and operates the store, which supplies products to Gloucester residents. (Courtesy of Jean Carr.)

In 1924, Frank Anello Sr. opened the doors at his barbershop at 204 King Street. At the age of 81, his son Frank Jr. continues to operate the barbershop. For over 89 years, the business has been at the same location and is the oldest family-run business in Gloucester City. (Courtesy of Frank Anello Jr.)

Duffy's Delicious Candies started out in 1922 at 228 Fourth Street. In the 1950s, it moved its retail operation to 35 North Broadway. Duffy's still operates at the same location. The same family has owned the business throughout the years. This is an inside view of the store in the 1960s. (Courtesy of Mike Hall.)

Last Call To Make Your

Easter Selection

AT

DUFFY'S

Everything for Children and Adults Alike!

Delightful Assortment
Easter Toys and Baskets
Bite Size Easter Eggs

$1.35 lb.

(Either in white or dark coating)

DECORATED EASTER EGGS

30c — 60c — $1.15 and up

We wish to thank our customers for their patronage. Also it would be appreciated if, during the last minute rush they would arrange to carry all packages with them.

Attractive selection of American Greeting Cards for Easter and every occasion.

35 N. Broadway

Easter BASKETS

All of the confectioneries are still made by hand in small batches. This advertisement is from 1963. Although the prices have changed, many people from town still get their Easter candy there each year. (Courtesy of the Parent family.)

Eight

EVENTS AND RECREATION

Gloucester City has always been an active community. Since the first factories located along the riverfront, local workers longed for recreation. In the early years, factories sponsored baseball teams that would play against each other. Other athletic clubs were organized for children. For over 100 years, the city has taken pride in observing Memorial Day for those who gave their lives for America's freedom. For fun, locals with musical talents created bands, which often performed at events. After World War II, the Garden State String Band was founded. This led to the annual String Band Parade in town. There were always plenty of activities for children to participate in, such as swimming in a lake or at the community pool. Each fall in the early 1900s, the city would hold a festival called Volkfest Verein, which would occur in Old Dutch Park, located in the Pine Grove section. The highlight of the festival was the construction of a column made entirely of fruit, as shown in the photograph. (Courtesy of Frank Anello Jr.)

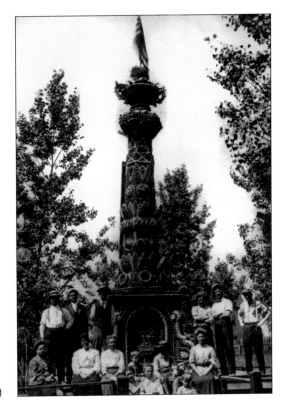

Throughout the years, there have been many types of athletic clubs in the city. The Oriental Athletic Club was organized in 1909. Members pictured are, from left to right, E. Jackson, financial secretary H. McAlhone, president J. Scott, vice president J. Barns, and recording secretary B. Cheeseman Sr. (Courtesy of Frank Anello Jr.)

Members of the Daughters of the American Revolution are seen celebrating Constitution Day on September 17, 1936. The women gathered at the Camden County Park, which was along the riverfront, in their best hats and dresses to honor this day in American history. (Courtesy of Frank Anello Jr.)

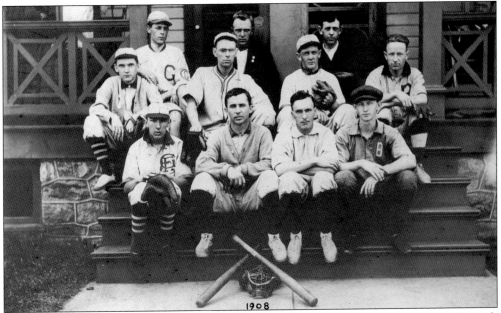

Baseball clubs were another form of activity that locals took part in the first half of the 20th century. Each neighborhood in town had its own team. Here is the 1908 Gloucester Field Club baseball team. Members are, from left to right, (first row) Earnest Barett, Rot Lane, Raymond Adams, and Daniel Batezel; (second row) Henry M. Evans, unidentified, Vernon Jones, and Clifford Zane; (third row) Neil L. Jamieson Sr., Ben Batten, and Howard Miller. (Courtesy of the Walter E. Callahan collection.)

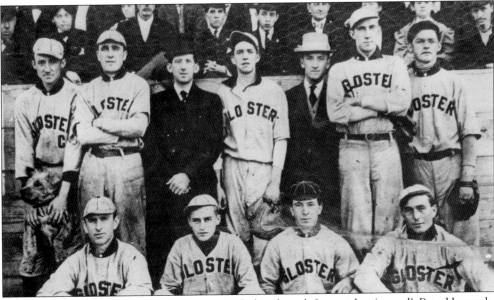

The 1912 Gloucester City baseball team includes, from left to right, (seated) Pete Howarth, Bill Hoezle, Sam "Lefty" Arnold, and Frank Ziegler; (standing) Harry Black with dog Rags, Ed McElhone, manager Bill MacMann, Bill McEllis, assistant manager Harry Robinson, Dave Black, and Leon Van Hest. The reason for the spelling "Gloster" is unknown. (Courtesy of the Albert Corcoran collection.)

Local historian David Doran, wearing the bowler at far left, is visiting with some gypsies who are camping out at what was known as the "Bone Boilers" section of the city. Today, this is the area around Baynes and Sparks Avenues. (Courtesy of Shad Agar.)

During the resort years, hot-air balloon ascensions were very common in the area of town by the racetrack. This activity was considered high tech at that time. This was one of the many attractions along the waterfront when the city was a thriving getaway destination. (Courtesy of Shad Agar.)

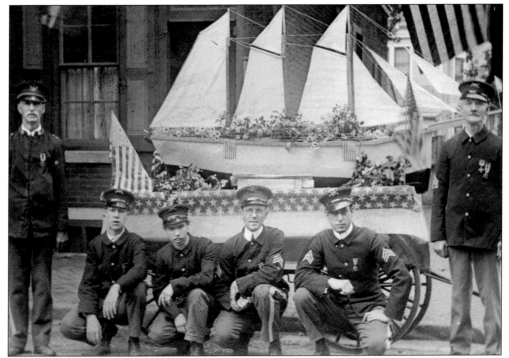

Beginning in 1901, John Owens would build a different boat each year for the annual Memorial Day celebration. Owens is pictured here on the right. The four men in the center are unidentified, but on the left is Henry S. "Pop" Holmes, a local veteran of the Mexican-American War, various American Indian Wars, the Spanish-American War. (Courtesy of the Joseph Stancliffe collection.)

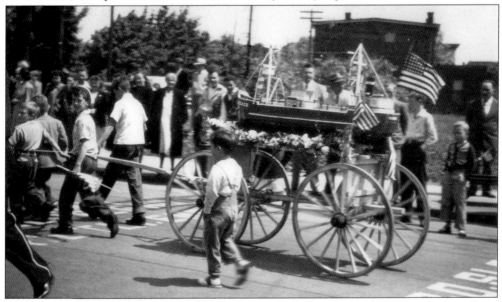

In the annual event, Boy Scouts pull a wagon through the streets of town to the launching dock. Once the parade ended at the river, the model ship would be towed out into the channel and released. Three gunshots were fired to honor those sailors who were lost at sea. (Courtesy of Frank Anello Jr.)

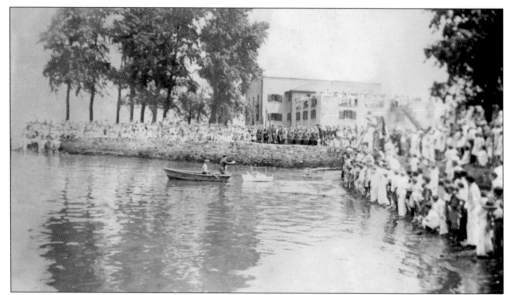

As far back as the early 1900s, the city took a lot of pride in the observance of Memorial Day. Yearly, there was a parade to each of the three cemeteries in the city in order to honor the men who had sacrificed their lives for the country. Afterwards, the procession would make its way to the Delaware River so that a model boat could be launched in honor of the people who died at sea. (Courtesy of the Joseph Stancliffe collection.)

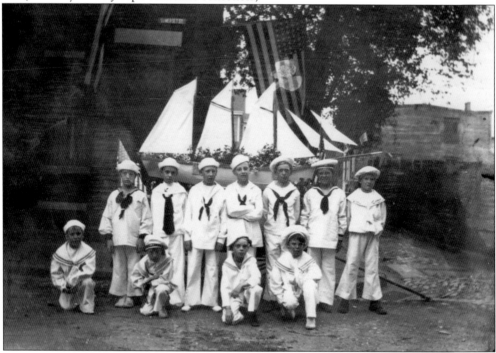

The Sea Cadets are posing in front of one of the ships before the ceremony starts. John Owens made his last ship at the age of 92. From 1901 to 1949, he handcrafted over 48 different types of vessels. Although scaled down, this tradition still continues today in Gloucester City. (Courtesy of the Joseph Stancliffe collection.)

Howlette's Yankee Kids & Drum Corps was organized in 1904. For the group, it became a tradition to parade around town in order to celebrate the New Year. In the early 1900s, each neighborhood created a different organization. Many of the Gloucester City groups would march in the New Year's Day Mummers Parade in Philadelphia.

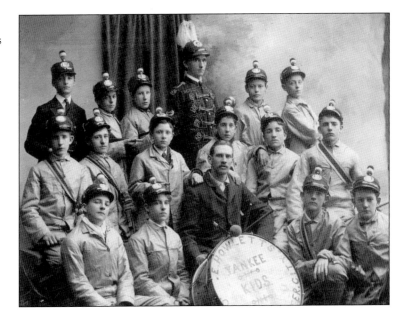

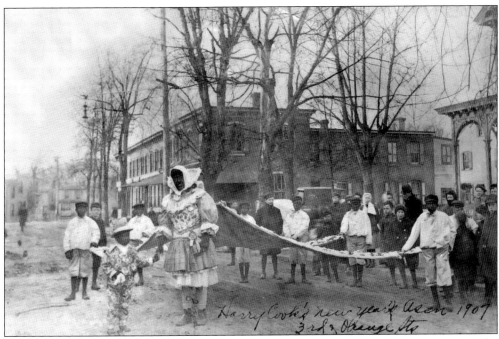

In the early 20th century, residents would celebrate with their neighborhood association. The locals would dress up and parade around the city. The women in town would bake layer cakes and hand them off to the paraders. All of the cakes would be displayed at city hall, where a large eating party would occur for everyone. Seen in this 1907 photograph are Harry Cook (tall figure near center) and his group of revelers ready to parade through the streets. (Courtesy of Shad Agar.)

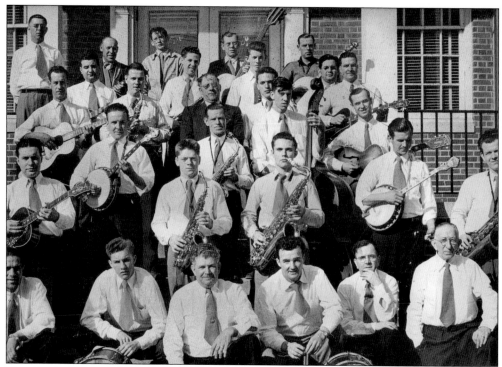

The Garden State String Band was formed in 1948. Some of the original members were Bob Dickenson, Ray Pine, Mr. Kelley, Frank Thompson, Dick Vervelle, Mr. Gerrelle, Frank Anello, Bob Hessington, Norm Murphy, Harry Vervelle, Ralph Anello, Matt Ready, John Gallagher, Roy Martorano, Howard Bastine, Tom Larney, Bob Cheesemen, Harry King, Jim King, Joe Jordell, Wally Funk, Bill Stumm (captain), Jim Coyle, Scott Prentice, and Jake Hutchinson. (Courtesy of Frank Anello Jr.)

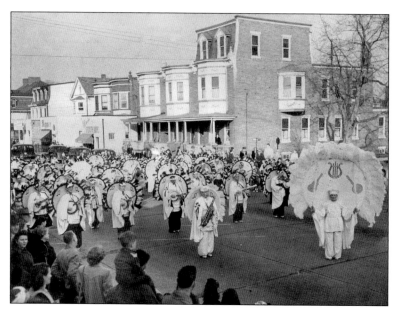

In 1949, the Garden State String Band parades down Broadway. Every April for 50 years, the city hosted an annual String Band Parade. Groups would come from far and wide to perform their New Year's acts on the streets of Gloucester City for the locals to enjoy. (Courtesy of Frank Anello Jr.)

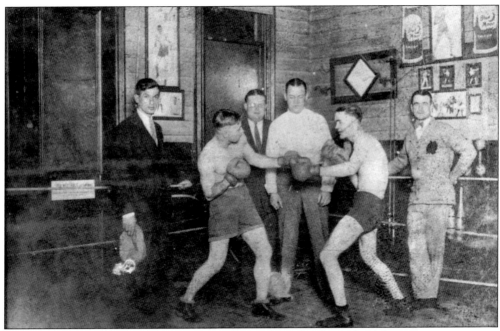

As far back as the resort years, there were boxing matches being held for spectators to enjoy in Gloucester City. From left to right, this posed photograph shows fight promoter Ted Ellick, fighter Sailor "Nick" Nickols, announcer Archie McNew, referee "Pose" Robison, fighter "Tommy" Lyons, and Pat Lyons. Many matches took place in the area, and in the county park during the summer months when the weather was too extreme to fight indoors. (Courtesy of the Funk family collection.)

In 1954, this was Powell's Luncheonette, which was owned by Sadie and Mike Powell. The business was located at 30 South Broadway and was just a few minutes walk from the high school on Cumberland Street. The following, from left to right, are just some of the kids who frequented the place at that time: (first row) Jack Rittenhouse, Carol Smith, Bob Bevan, Tommy Feller, George Bakely, and Henry Lim; (second row) Joe Storms, Julie Campbell, Harriet Plews, Barbara Ann Kasa, Carole Thompson, Judy Avis, Bunny Papperman, and Ralph Holloway. (Courtesy of Carol [Hurff] Ritchie.)

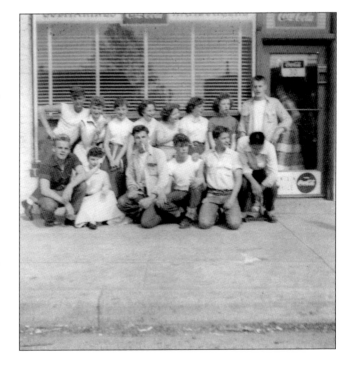

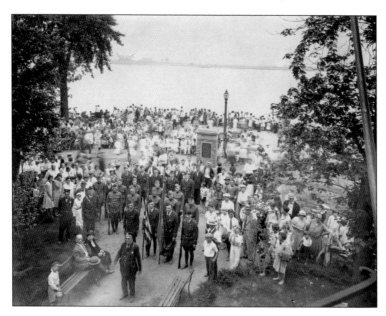

In the late 1920s, the Camden County Parks Commission took ownership of the land where Hugg's Tavern and the boathouses stood. All of the buildings were demolished in order to make way for a park. This image was taken during the dedication ceremony of the newly constructed park. It now is now at the corner of King Street and Jersey Avenue and is known as Proprietors Park.

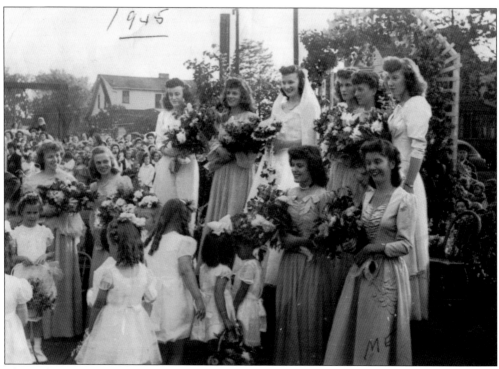

The tradition of celebrating May Day dates back over a thousand years. The celebration consists of young children singing around a pole tied with colorful streamers or ribbons followed by the crowning of a May Queen. In this 1945 image, the contestants are, from left to right, (first row) unidentified, Elise Shaeffer, Louis Crouthamel, and Grace Smith; (second row) Elene Stockie, Jane Laute, Shirley Garwood, Miriam Crouthamel, Waleska Kahlan, and Dorothy Netter. (Courtesy of VFW Museum Post 3620.)

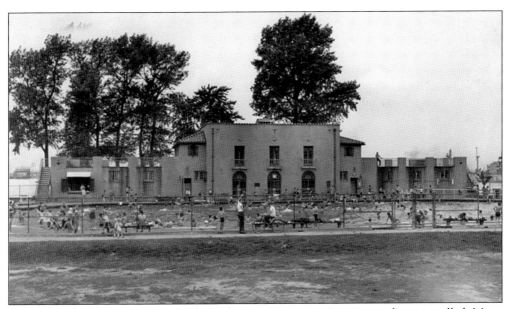

When Camden County constructed a park, a community swimming pool was installed. Many children looked forward to cooling off on a hot summer's day in the large pool. Dances were sometimes held on the second floor of the pool house. The building and pool were closed and torn down in the mid-1970s. (Courtesy of Shad Agar.)

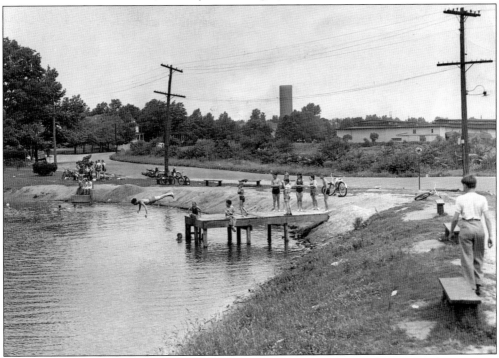

If local children did not have enough money to swim at the county pool, there were other options. In the 1960s, a local teenager is diving off the dock at Martin's Lake, which is located along Johnson Boulevard. The small pond is fed by a natural spring and was an ideal spot to take a dip during the hot summer months in the city. (Courtesy of VFW Museum Post 3620.)

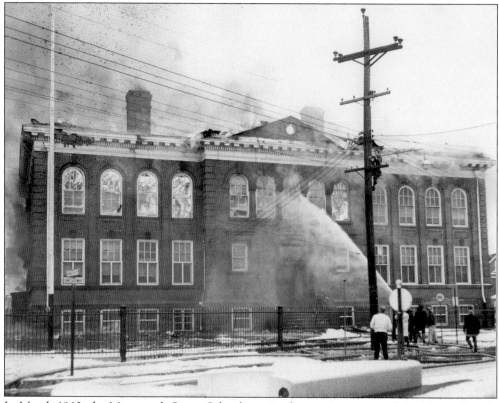

In March 1960, the Monmouth Street School met its demise. It was one of the biggest fires in the city's history. The fire's intensity was magnified by high winds, and the structure was quickly devoured. (Courtesy of Ed Birch.)

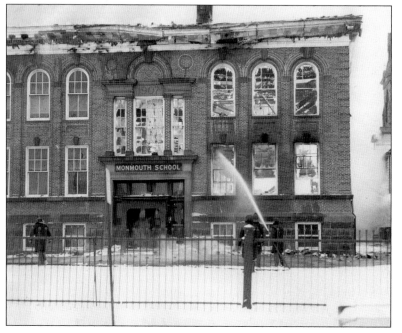

Fire departments from nearby towns also helped to respond and assist city firefighters in battling the blaze. On the right of this image, from the Bergen Street perspective, the still intact steeple of St. Mary's Church is visible.

The fire's sparks eventually set ablaze the 160-foot-tall wooden steeple of St. Mary's Church and quickly engulfed the 72-year-old structure, causing it to come crashing to the ground. (Courtesy of the Harry Demarest collection.)

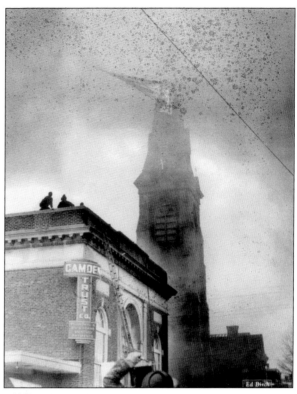

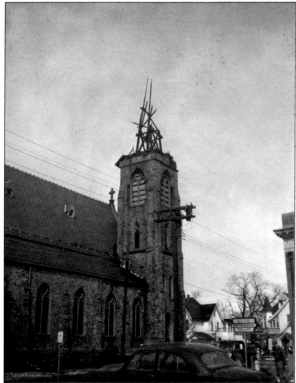

After this devastating fire, the entire school building and the church steeple were gone. The Catholic parish replaced the steeple with a stainless steel structure, and years later, its replacement would be the first steeple in the western hemisphere to install LED lighting. The school was never rebuilt, and in its place today is a bank building.

Another type of entertainment in the early 20th century was to see a motion picture at Young's Majestic Movie House. This nickelodeon, charging only 5¢ for admission, was located at King and Middlesex Streets. Pictured in 1910 are movie patrons, from left to right, Lew Parker, unidentified, Charles Callahan, Al Burgess, and Mayor Boylan's son.

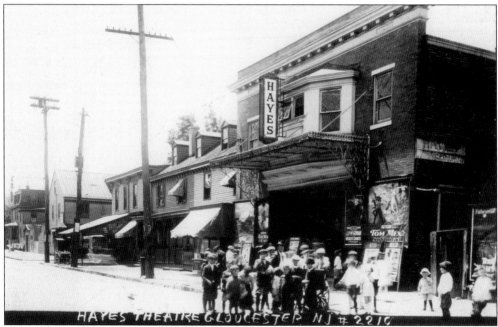

This theater was originally called King's Place but was renamed Hayes Theatre. Mommy Hayes, the proprietor, would show top-rated films of the time and would also provide more risqué vaudeville or burlesque films. The building is located on Burlington Street and has a new life today as the local VFW post and military museum. (Courtesy of VFW Museum Post 3620.)

LEADER THEATRE

Cool, Comfortable, Inviting Gloucester's Greatest Summer Resort

FRIDAY AND SATURDAY:

FREE AND EASY

A Million Laughs!

A Score of Stars!

The Leader Theatre was located on Burlington Street and was run by a woman named Mommy Hayes. The theater was small, and when attendance grew, Hayes moved to a larger place across the street. This advertisement is from 1930 and was placed in the *Gloucester City News*. (Courtesy of the Parent family.)

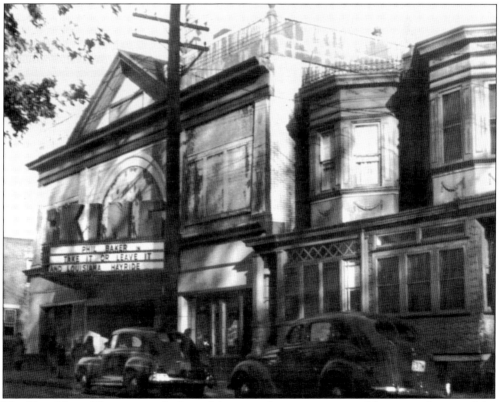

The King Movie Theatre was the last of the movie houses to survive. The original name of the theater was the Apollo. It was located on the corner of King and Somerset Streets. The Apollo held dance recitals and high school graduations in addition to presenting vaudeville and motion pictures. The building was torn down in the 1980s. (Courtesy of VFW Museum Post 3620.)

Waleska Kahlan receives the first mail delivery at her home on Nicholson Road in 1951. Postman James Riley is conducting the first local door-to-door mail service, the newest convenience for the Gloucester Heights section of the city at the time. Prior to home delivery, residents of the Heights would have to go to the post office to pick up their mail. (Courtesy of Reilly family collection.)

On May 21, 1955, county officials are in attendance for the ribbon-cutting for the reopening of the newly reconstructed concrete roadway along King Street. This type of ceremony occurs rarely today.

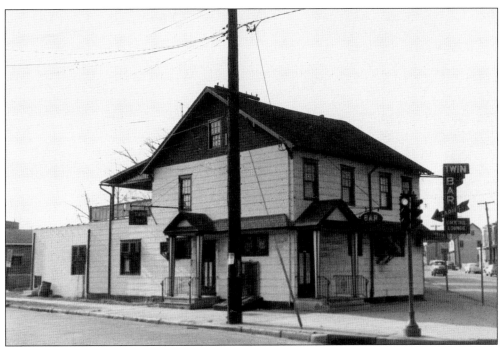

Gloucester City is considered one of the birthplaces of rock and roll. In 1952, at the Twin Bar on the corner of Market Street and Broadway, the featured act was Bill Haley and The Saddlemen. Performers such as Haley would rock the joint for rockabilly fans. Sally Star appeared there regularly, as the bar featured country-and-western bands as well. Today, there is still a tavern at this location. (Courtesy of the Louisa Llewellyn collection.)

This is an advertisement for the bar from the *Gloucester City News*. (Courtesy of the Parent family.)

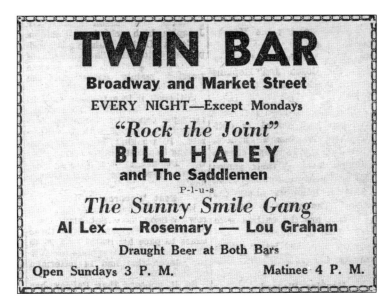

TWIN BAR

Broadway and Market Street

EVERY NIGHT—Except Mondays

"Rock the Joint"
BILL HALEY
and The Saddlemen

P-l-u-s

The Sunny Smile Gang
Al Lex — Rosemary — Lou Graham

Draught Beer at Both Bars

Open Sundays 3 P. M. Matinee 4 P. M.

Many of the younger children, who were too small to swim in Martin's Lake by themselves, could always enjoy the wading pool at the top of the hill, which overlooks the lake. Today, this structure is still recognizable in the park, but it has been filled in and converted to a gazebo. The large building in the background belongs to J.R. Quigley Lumber Yard. (Courtesy of the Funk family collection.)

The dedication of the new city hall took place in the 1940s. The building was constructed on the site of the original city hall. It housed the fire and police departments, courts, and municipal offices.

This photograph shows part of the Fourth of July Parade in 1957. This location is the northeast corner of Broadway and Market Street. For years, the McGlennon family operated a garage and service station here. (Courtesy of VFW Museum Post 3620.)

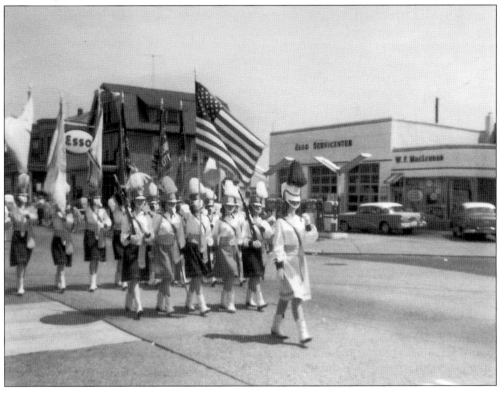

www.arcadiapublishing.com

MAP SEARCH

Discover books about the town where you grew up, the cities where your friends and families live, the town where your parents met, or even that retirement spot you've been dreaming about. Our Web site provides history lovers with exclusive deals, advanced notification about new titles, e-mail alerts of author events, and much more.

Arcadia Publishing, the leading local history publisher in the United States, is committed to making history accessible and meaningful through publishing books that celebrate and preserve the heritage of America's people and places. Consistent with our mission to preserve history on a local level, this book was printed in South Carolina on American-made paper and manufactured entirely in the United States.

Find Your Place in History.